Andy Warhol

Andy

YALE UNIVERSITY PRESS NEW HAVEN & LONDON

Warhol

Arthur C. Danto

Published with assistance from the Mary Cady Tew Memorial Fund.

Set in Janson type by Tseng Information Systems, Inc.
Printed in the United States of America.

Library of Congress Cataloging-in-Publication Data
Danto, Arthur Coleman, 1924–
Andy Warhol / Arthur C. Danto.
p. cm. — (Icons of America)
Includes bibliographical references and index.
ISBN 978-0-300-13555-8 (hardcover : alk. paper)
1. Warhol, Andy, 1928–1987—Criticism and interpretation. 2. Art and
society—United States—History—20th century. I. Title.
N6537.W28D36 2009
700.92—dc22 2009021638

A catalogue record for this book is available from the British Library.

This paper meets the requirements of ANSI/NISO Z39.48-1992
(Permanence of Paper).

10 9 8 7 6 5 4 3 2

Icons of America
Mark Crispin Miller, Series Editor

Icons of America is a series of short works written by leading scholars, critics, and writers, each of whom tells a new and innovative story about American history and culture through the lens of a single iconic individual, event, object, or cultural phenomenon.

To Barack and Michelle Obama,
and the future of American art

Contents

Preface

There is no way in which I could write a new biography of Andy Warhol. My competence lies elsewhere. Fortunately, there are several quite good "lives" of Warhol that I could draw on, since my book is, roughly, chronological, and such writers as Victor Bockris, David Bourdon, and, more recently, Steven Watson have, collectively, constructed a fair narrative of Andy's life— of how he lived and how he died—and they had the benefit of knowing him and many of those around him. I have nothing to contribute to that. As a writer, I have published in philosophy primarily, including the philosophy of art; and secondarily as an art critic, chiefly in *The Nation*, a magazine of opinion which, beginning with Volume One, Number 1, on July 4, 1865, has always had an art critic. There is a connection between the two endeav-

ors, and between them and this book. My philosophy of art was developed in two pieces of writing—an article titled "The Art World," published in the *Journal of Philosophy* in 1964, and, in 1981, a book, *The Transfiguration of the Commonplace*. Both of these were responses to developments in contemporary art that took place mainly in New York, in the 1960s, among them two exhibitions by Andy Warhol, held at the Stable Gallery, in 1962 and in 1964. The work in both these shows, but especially in the second show, necessitated, so it seemed to me, an entirely new approach to the philosophy of art, and I think that most aestheticians and philosophers of art would agree that the writings just mentioned must be given substantial credit for redirecting the philosophy of art to take account of the immense artistic revolution that took place in the early to mid-1960s, in which, as an artist, Andy Warhol played a prominent role. But the art through which Warhol achieved historical importance was internally connected with his candidacy as an American icon. He was able to achieve iconic status because of the content of his art, which drew directly from, and which indeed celebrated, the form of life lived by Americans, including what Americans ate, and who Americans considered icons in their own right, mainly figures from mass culture, like movies and popular music.

In a way, Warhol transcended his chosen subjects in the eyes of the world. His art was typically interpreted by European intellectuals as critical both of American mass culture and of the products of American capitalism, like Campbell's soup. Seen as a critic of

American culture, Warhol—and the Pop artists generally—were given considerable credit by Europeans, and were taken seriously by them as artists in a way that they were not, at first at least, by the American art world, which had finally begun to accept the fact that America had, for the first time in history, produced world class art through the paintings of the so-called New York School—the great Abstract Expressionist canvases produced during and after World War II. In American art circles, it came as a shock that the Pop artists should repudiate this immense aesthetic achievement, and paint what looked like simpleminded pictures of soup cans or Donald Duck. It was widely felt that important painting had to be difficult—but anyone in the culture could get what Pop art showed immediately. Whether the Europeans were right or not, that Pop art was critical of American culture, they at least felt that there was more to the new art than met the eye. Andy, at least, seemed eager to present himself to the European art world as anything but frivolous. He and his dealer, Ileana Sonnabend, were at odds over how his first show at her gallery in Paris should be presented. He wanted to call it "Death in America," and to consist of paintings of car crashes, race riots, and electric chairs, and be based on silk-screen images of tabloid newspaper photographs, but often in candy colors. In the end Sonnabend accepted the content, but not the title. It was simply called "Warhol." It was certainly a serious show, which the Europeans respected. He could not have had that show in America at that point—January 1964.

The European art world in the twentieth century was necessarily more complicated than the American art world, because more was at stake. Art in Europe was heavily politicized. Abstract art, for example, under both Hitler and Stalin, was politically unacceptable. It remained unacceptable in Soviet Russia throughout the Cold War. German artists, on the other hand, came to feel, after World War II, that abstraction expressed the political values of democracy. And since under Hitler, a certain kind of kitschy realism was felt to express the values of National Socialism, figural art became politically suspect after the war. So by the 1960s, when Pop art seemed to question the values of Abstract Expressionism, it seemed a particularly liberating moment. Pop seemed politically important in Germany because it seemed to repudiate abstraction. This increased Warhol's stature on the Continent. He was seen not only as a critic of capitalist production, but as a critic of American high culture as well. When the first serious monograph on Warhol, by Rainer Crone, was published in Germany, it became a best seller. It took a long time for Warhol to become intellectually respectable in America. Instead, he became an icon. He became part of the culture he celebrated—a star who loved hotdogs and Coca-Cola, and worshipped Marilyn and Elvis.

My own interest in Pop art, and especially in Warhol, lay elsewhere. I had moved to New York after the war because of the immense excitement I found in the art of the New York School, in which I had hopes of making a career as an artist. I was a vet-

eran, with educational benefits that I decided to use to study philosophy. Though I had some success as an artist, philosophy proved to be more interesting to me, and when the 1960s began, I was a tenured professor at Columbia University, on sabbatical in Europe, where I was writing my first book. It was at the American Library in Paris that I saw my first piece of Pop art as a black-and-white reproduction in *ARTnews*. It was called *The Kiss*, by Roy Lichtenstein, and it looked like it had been cut out of the comics section of an American newspaper. Suffice it to say that I was stunned. I was certain that it was not art, but as my year in France unfurled, I came increasingly to the view that if it *was* art, anything could be art. I made up my mind to see as much Pop art as I could when I returned to America.

I am no more interested in writing an autobiography than I am in writing a new biography of Warhol, but I feel it important to explain his importance for me, as well as to prepare the reader for the emphasis of this book. It is really no more a piece of art history than it is a biography, but rather a study of what makes Warhol so fascinating an artist from a philosophical perspective. Visiting his second show at the Stable Gallery in April 1964 was a transformative experience for me. It turned me into a philosopher of art. Until that point, great as my interest in art and especially in contemporary art had been, I had no special interest in the philosophy of art itself. I simply saw no interesting way to bring philosophy and art together. The show consisted of hundreds of what looked like commonplace grocery boxes, piled

up as they would be in a supermarket stockroom. Among these were *Brillo Boxes*, which looked like the real thing. The Brillo box might be considered an American icon, I suppose, but only because Andy Warhol made it one. It is his most famous work and I consider it his masterpiece, for reasons I shall give in the course of this book. It is, as a piece of commercial design, a knockout. Ironically its designer was a commercial artist with high ambitions as a fine artist—in fact he was an Abstract Expressionist, named James Harvey, from Detroit. But for me the question was not what made it so good but what made it art. The *Brillo Box* helped me solve a problem as old as philosophy itself, namely how to define art. More even than that, it helped explain why that is a philosophical problem in the first place. Needless to say, an adequate definition of art had to cover art in a universal way. It has to explain why the *Mona Lisa* is art, why *Rigoletto* is art, why *Washington Crossing the Delaware* is art. It has to explain why anything is art. A lot of people in those years were quite prepared to say that the *Brillo Box* was not art. I felt that they were wrong, of course, and I really loved *Brillo Box*. But the nice thing about it for philosophy was that it is so simple a work—a mere oblong box with printing on its top and sides. Nothing complex about it, really, in comparison with your typical piece of Abstract Expressionist painting.

What makes Andy an icon, of course, is not that he is so instructive philosophically, though that is an important aspect of his virtue as an artist. What makes him an American icon is that

his subject matter is always something that the ordinary American understands: everything, or nearly everything he made art out of came straight out of the daily lives of very ordinary Americans. Anyone who lives the American form of life can tell you what a grocery box looks like, and where to find one, and what you want one for. Or can tell you where to find a can of Campbell's soup, how to prepare it, and in general how much it costs.

The commonplace world of everyday industrial objects has of course been looked down upon, aesthetically, by those who cherish good taste. And the commonplace imagery on billboards and in comic books and pulp magazines has been considered aesthetically irredeemable by the same arbiters of aesthetic judgment. Fast foods pollute the body the way the comics, not long ago, were felt to corrupt the mind. When I was a student in Paris, Coca-Cola was held to cause cancer. America was, to cite a title by the expatriate Henry Miller, an "air conditioned nightmare." In the nineteenth century, the Art and Crafts Movement condemned industrially manufactured furniture. Art, until 1960, stood implacably against the common culture in this sense. All at once in the early 1960s there were real artists who took the contrary position, celebrating the vernacular in paintings that appropriated the flat colors and heavy outlines of commercial art. The tastes and values of ordinary persons all at once were inseparable from advanced art. That art, from my perspective, showed the way to bring to the muddles of aesthetics the clarities of high analytical philosophy. Without Warhol, I could never

have written *The Transfiguration of the Commonplace*. This book accordingly is the acknowledgment of a debt.

I never met Andy Warhol, though I stood next to him at the opening of an exhibition of a body of prints—*Myths*—at the Ronald Feldman Gallery in Soho, while he autographed an announcement of the show for my new wife, Barbara Westman. Occasionally I caught a glimpse of him at a party, or at a show. We lived very different lives. Philosophy was so distant from the downtown New York life he lived that when, in "The Art World," I wrote that "Mr. Andy Warhol, the Pop artist, displays facsimiles of Brillo cartons, piled high, in neat stacks, as in the stockroom of the supermarket," I was reasonably certain that no reader of the *Journal of Philosophy*, where this was published in 1964, had a clue whom I was talking about. Few philosophers were likely to haunt the Stable Gallery, the Green Gallery, or even the Janis Gallery, where Pop was on view. Years later, after I had become an art critic as well as a philosopher, my wife and I attended the auction of Andy's estate and marveled at the exquisiteness of his taste in French Art Deco furniture, as well as in art. In this, as in everything, he was ahead of his time, even if he knew nothing better to do with his extraordinary swag than pile it up, as in a treasure chamber, in his East Side town house.

Acknowledgments

I am particularly grateful to Professor Bertrand Rougé of the University of Pau for his objections to my view of Andy Warhol's installation at his second exhibition at the Stable Gallery in Manhattan, in April 1964. These appear in *The Philosophy of Arthur Danto*, in the series *The Library of Living Philosophers* (The Open Court Press, 2009). My current view of that show owes a great deal to having had to deal with Rougé's perception. The features of the individual grocery boxes have to be explained with reference to how they should look in supermarket stacks. That concession leaves intact the ontological character of how to account for the differences between the actual boxes of the *Lebenswelt*—the world of common experience—and the somewhat Futuristic, somewhat design-y, style of the Warhol cartons. Art historically speaking, they are late examples of *Arte Metafisica*.

Few of the corrections I owe to others have required this degree of rethinking: mostly they have been accepted as gifts, as has their readiness to read my work. I owe an inexpressibly rich debt to David Carrier for a long and searching correspondence. My gratitude to my wonderful colleague, Lydia Goehr, is existential. Alison McDonald has brought a vast art world knowledge to her reading of the text. Noel Carroll has been a constant source of philosophical knowledge and artistic understanding. Richard Kuhns is the indispensable friend of a lifetime: I could not write anything that meant anything without seeking his wisdom and human awareness. I owe to Ti-Grace Atkinson what special knowledge I may have of the devious Valerie Solanas, my sensitivity to the deep issues of feminism—and I cherish the truth that the master painter Sean Scully has never allowed his uncertainty regarding this book's subject in any way to stand in the way of acknowledging the certainty of his friendship with its author. Finally this book and many of its peers owe their existence to Georges and Anne Borchardt, and their acumen, literary and practical. And for the beauty of her soul, her marvelous sense of comedy, her keen eye and her good sense and the gift of her love, I have been blessed—*blessed!*—by my marriage with Barbara Westman.

A Note on Notes

The format is simple. Parenthetical references in the text are to the books listed in the bibliography. I have placed a word that refers to a title, together with page numbers. I have sought a readable text, in enjoyable language, and have kept references to a minimum.

Andy Warhol

The Window at Bonwit's

In Victor Bockris's biography *Warhol,* there is a chapter titled "The Birth of Andy Warhol: 1959–61." This obviously does not refer to Andy Warhol's birth as a baby, which took place in 1928, in Pittsburgh, to immigrant Ruthenian parents. It refers, rather, to a set of changes in Warhol's identity—the breakthrough, in effect, through which he became an icon. One of the works that helps visualize the breakthrough is a painting done in 1961, which consists in a greatly enlarged version of a simple black-and-white advertisement of the kind that appears in side columns and back pages of cheap newspapers. It advertised the services of a plastic surgeon, and showed two profiles of the same woman, before and after an operation on her nose. The left profile shows her with a large, witchlike nose, the right one with a cute turned-up nose, like a cheerleader's or a starlet's—the kind of nose that readers

with beaky noses dream of having. Since we read from left to right, there is a relationship of before and after between the two images, and indeed Warhol titled his work *Before and After*, of which he painted several versions. As such, it was the embodiment of the kind of dream that haunts people concerned with changing their looks in order to be, they think, more attractive. Replacing *before* with *after* is the path to beauty as they conceive it, and to happiness.

The years 1959 and 1961 constitute a zone of biographical change between two stages of Warhol's life, a zone of transfiguration. He was transformed from a highly successful commercial artist into a member of the New York avant-garde—something he lusted after with all the passion of Miss Big Nose yearning for the look of Miss Tiny Turned-up Nose. It was a transformation underscored by the imagery of *Before and After* as art. Before Warhol, *Before and After* would have been a piece of boilerplate commercial art, whose maker would be long forgotten. By 1961, greatly enlarged, it became a work of high art. Reproductions of *Before and After* before and after this transformation took place look exactly alike. The difference, one might say, is invisible. Part of what made Warhol the icon he became has to do with the fact that initially almost nobody would have acknowledged a difference between the two images. Warhol did not simply replicate a grungy piece of commercial art. He made the distinction between a piece of grungy art and a piece of high art at once invisible and momentous. But that meant that he changed not so

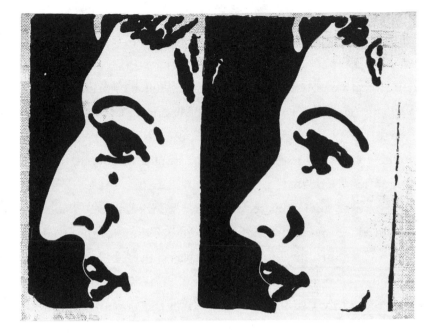

Before and After: American Iconic Dream. Andy Warhol, *Before and After,* 1960.
Synthetic polymer paint and silk screen ink on canvas, 54 × 70 in. © Copyright
The Andy Warhol Foundation for the Visual Arts/ARS, NY

much the way we look at art but the way art was understood.
That meant that between 1959 and 1961, the seeds of a visual and
indeed a cultural revolution were planted.

What happened when Andy Warhol became the cultural icon
Andy Warhol was not simply a biographical transition, in which a
successful commercial artist became a serious avant-garde artist.
It was a social transition, in that certain individuals of great im-
portance in keeping track of the frontiers of art recognized that
Warhol had done something of significance as far as the shape of

that frontier was concerned. Artistic change has to be recognized and accepted as such by what we shall designate (to follow usage) as "the *art world*" of that time—certain curators, dealers, critics, collectors, and, of course, other artists. That art world was in this respect prepared for Andy Warhol. He entered an ongoing discourse, and contributed to the direction this discourse took over the next years. By itself, that did not suffice, of course, to make him an icon. For that, a culture far wider than the art world of the very early 1960s was required, and Warhol himself had to be perceived in ways that went far beyond questions of the frontiers of art. Certainly, his being an artist was central in his becoming an icon—but how many artists, after all, go on to become icons? Very few. Only Warhol, for example, in the Pop art movement, who collectively changed the face of art in the mid-1960s, in fact rose to iconic stature. Roy Lichtenstein, Claes Oldenburg, Jim Dine, Tom Wesselman, and James Rosenquist were the chief Pop artists, and none of them really became icons save within some sector of the art world, if even there. They were each wonderful artists. But Warhol was to become *the* artist of the second half of the twentieth century. He became an artist for people who knew very little about art. He represented an ideal form of life that touched his world from many sides. He embodied a concept of life that embraced the values of an era that we are still living in. In certain ways he created an iconic image of what life was all about. No other artist came close to doing that.

The change from artist to icon happened fairly rapidly. By

1965, for example, the transformation was complete. In October of that year, Andy and his "Superstar," Edie Sedgwick, attended his first American retrospective exhibition at the Institute of Contemporary Art on the campus of the University of Pennsylvania, in Philadelphia. There was a crowd of at least two thousand rapturous persons, most of them students. No one had expected a crowd that large, and the curator, Sam Green, to be prudent, removed most of the paintings from the walls, leaving the gallery all but bare. But the crowd had not come so much to look at the art as to see Warhol and his consort. Chants of "Andy and Edie! Andy and Edie!" went up. People were jostled and trampled. It became a problem of crowd control much like what was happening at rock concerts. Andy, Edie, and their party found safety on an iron staircase, where, like demagogues on balconies, they waved at the crowds below. Finally a hole was axed in the ceiling, and the celebrities were able to escape to the floor above. Crowd behavior like that was almost standard with certain dreamboat musicians, like the Beatles, or Frank Sinatra before them. But it was unheard of at art events, where the institutional atmosphere of the museum enjoined quiet and respect. The change did not escape Warhol's notice. "To think of it happening at an art opening," he said. "Even a Pop Art opening. But then, we weren't just at the art exhibit—we *were* the exhibit" (Bourdon, 213–14).

The history of Modernist art was a history of anger and resentment. As far back as the Salon des Refusés of 1863, on the instruction of Louis Napoleon, paintings rejected by the selection

committee were hung in a separate gallery, where viewers could make up their own minds. Manet's *Déjeuner sur l'herbe* was the target of jeers and shouts of derision. There were riots in Paris when Alfred Jarry's *Ubu Roi* was first presented, or when Stravinsky's *Sacre de Printemps* was first performed. There was jeering in the gallery where Matisse and the Fauves were displayed in the Salon of 1905. This did not happen with art in the 1960s. On the contrary, it was felt, particularly by younger audiences, to be their art, to be part of *their* culture. By 1965, everyone knew in a general way the kind of art Warhol was making. The crowds at the ICA created, spontaneously, an event that would not have arisen with Lichtenstein or Oldenburg, and certainly not for the painters in the previous generation of Abstract Expressionists. Nor really did it happen anywhere with Minimalist art, which replaced Pop as the mainstream avant-garde art in the mid-1960s. Pop art's successor was pretty much a big yawn as far as the general population was concerned. But with Pop, the change in art was perceived as radical, the meaning of art for ordinary persons had changed, and much of this was something that Warhol had done. At least, in his case, because of his art he had begun the ascent to the status of an icon.

But let's return to "The Birth of Andy Warhol," and the period in which he had painted *Before and After*. No one can have known that, with the change in decade, from the 1950s to the 1960s, the whole of Western culture was entering a period of convulsive change. No one could have anticipated the tremen-

dous change in attitude that lay ahead, especially in youth culture, in 1968. It was a decade in which boundary after boundary was broken and washed away. The boundary between vernacular and high art was breached in the very early 1960s. It was a way of overcoming the gap between art and life. My theory is that when there is a period of deep cultural change, it shows up first in art. The age of Romanticism first became visible in the way English gardens were laid out, "natural" as opposed to formal. In 1964, the Beatles made their first visit to America, wearing long hair, testing a boundary between the genders. That very year, the boundary between the races was attacked as Freedom Riders went into the American South to help black citizens redeem their civil rights. The campus upheavals of 1968 put under attack the boundaries between the generations, and young people claimed a right to determine the curriculum, and to study the subjects closest to them, including courses in ethnic and gender studies that would have been unheard of in the previous decade. But their demands went beyond the institution of the university, into the region where the most far-reaching political decisions were made. Meanwhile, radical feminism emerged in the late 1960s, putting under attack traditional boundaries between the lives of men and women, the latter demanding equality or even more, autonomy. In 1969, the Stonewall Riots put under attack the boundaries between straight and gay sexual differences, deeming them irrelevant to civil life. Late in the decade, Warhol created a kind of cabaret, with the in-house rock group The Velvet Under-

ground, and other entertainments, which he called "The Exploding Plastic Inevitable." "Exploding" and "Inevitable" somehow capture the volatility of change that marked the 1960s. But the transition from Andy Warhol, commercial artist, to Andy Warhol, art icon, while perhaps inevitable, was not explosive. It was, initially, an uncertain kind of groping toward an art that did not really exist yet, and an identity neither Warhol nor anyone close to him would have been able to pin down. And the "discourse" I spoke of, which he ultimately found a way to enter, was as yet ill defined and uncertain. That makes Bockris's metaphor of birth particularly apt. The fetus gropes blindly in the dark, heading toward a world it could not have visualized, in the warm cavity that had so far constituted its entire atmosphere.

There had to have been, in 1959 or 1960, some kind of internal change in Warhol. He had come to New York City as a graduate from art school, and had made it as an immensely successful commercial artist. The song says that if you can make it in New York, you can make it anywhere, but what Warhol meant to do was to make it in New York in a different way, at a different level and at whatever cost. He wanted to make it as a very different kind of artist. It is difficult to imagine that what he wanted to become was one of the Abstract Expressionists, who dominated the New York art world in those years. As we shall see, his first moves were made under the protective coloration of an Abstract Expressionist philosophy of pigment. But what one might call the Abstract Expressionist philosophy of *art* had, and could have had,

no appeal for Warhol. The view was that the painter reaches deep into his or her unconscious mind and finds ways to translate what Robert Motherwell called "the original creative impulse" into marks, impulsively deposited through broad gestures, onto the painting or drawing's surface. When Warhol said, in his aphoristic style, "If you want to know who Andy Warhol is, just look at my face, or at the surface of my work. It's all there," he was rejecting this romantic view of the artist's soul (*Andy Warhol: A Retrospective*, 457). The Pop artists and the Abstract Expressionists had markedly opposed conceptions of what artists did. The Pop artist had no inner secrets. If he revealed things to viewers, they were things the viewer already knew or knew about. For this reason, there was already a natural bond between artist and viewer, which entered, in Warhol's case, into the way he became an icon. He knew, and was moved by, the same things his audience knew and was moved by.

Beyond question, though Abstract Expressionism ran out of steam in roughly 1962, there was already in the late 1950s a revulsion against certain aspects of it as an orthodoxy—against, for example, what hostile critics spoke of as its "paint cookery." There was, for example, Hard-Edged Abstraction, which looked for well-defined forms and clean, uniform colors, where the artist controlled the relationships between shapes, and did not count on the accidentalities of touch and pigment that made the Abstract Expressionist surfaces so exciting. But this was not, one might say, the way that art wanted to move forward. Hard-Edge

attacked what seemed to constitute the heart of contemporary painting, namely the *expressiveness* of paint as paint, and the impulsiveness with which the painter interacted with it, and the spirit of improvisation and, indeed, liberation, that made Abstract Expressionism really unlike any movement in the history of art. Whatever was to replace it had to retain that or something of that. It was easy to understand how artists who had become masters through Abstract Expressionism, like Mark Rothko, could have thought that it would last a thousand years—as long at least as the Renaissance paradigms had prevailed. Abstract art had become an option around 1912 at the earliest, New York School abstraction with Jackson Pollock and Willem de Kooning in the later 1940s. It ran its course in less than two decades.

The successful rebellion had to take a different form from Hard-Edge Abstraction, and it had begun with artists who became *beaux ideals* for Warhol—Robert Rauschenberg and Jasper Johns, and, in a somewhat different way, Cy Twombly. Johns in particular had mastered the Abstract Expressionist brush. As a painter, he was at least the equal of any of the masters of the New York School. There was something delicious in the way he laid paint down on panels. But his subject was not himself, but commonplace forms from what phenomenologists speak of as the *Lebenswelt*—the world of common experience: numerals, letters, maps, targets. In a way, Johns sought subjects that everyone recognized, but he was particularly interested in the relationship between these entities and their representations. A painted numeral

just is a numeral, a painted letter just is a letter. A painted flag is a flag. That it is beautifully painted is neither here nor there. He found a way of turning reality into art, in the sense that his subjects overcame the difference between representation and reality. Rauschenberg worked with real things from the beginning. If he painted a real thing, it was in the most direct and literal way—he slathered paint on it. His famous "combine" *Monogram* consisted mainly of a stuffed angora goat with a rubber tire around its midriff. And he then slathered paint on the goat's head and parts of its body. His combine *Bed* was made of a quilt and a pillow fitted into a wooden bed frame and hung on the wall, and—of course—he slathered it in such a way that there would be little temptation to sleep in it. It was as if the presence of paint sufficed to turn reality into art. Twombly was more abstract then either of his friends. He scribbled on canvas, or on paper. His drawings and paintings were in this respect a bit gestural and in the spirit of Abstract Expressionism. They were primitive in the sense that scribbling was the kind of mark that real children really make. It stands to writing the way babbling stands to speech. But it was without question real. It surged across the surface, but it was not in any way arbitrary. It was something everybody knew.

These figures, and especially Rauschenberg and Johns, were powerful influences for Warhol. There was also the fact that they were lovers, as Rauschenberg and Twombly had been. The fact that they were gay interested Warhol greatly, since this was his own sexual orientation. They were very masculine, and for this

reason Warhol was diffident about approaching them. He said that he felt that he was "too swish" to find acceptance. The code of conduct of gay males was evolving in such a way that swish was decreasingly acceptable. The thrust was to be as aggressively masculine as possible. By the mid-1960s, Warhol changed his look completely. He became skinny. He wore leather jackets and blue jeans. He was seeking entry into two worlds, the art world and the gay world, as both had begun to evolve. The art that engaged him is not easy to characterize in sexual terms, but the art that had made him respected in the commercial world of the 1950s had been markedly effete. It was almost a form of folk art, with kittens and cherubs, in which his signature form was defined by a broken line filled in with pale bonbon washes in blue and pink, yellow and green. They often carried handwritten inscriptions, in his mother's engaging calligraphy. The aesthetic was that of upscale greeting cards. It was, in effect, the aesthetic of his commercial art, especially for I. Miller shoes—high-heeled pumps with fetishistic overtones. In a way, pictures of shoes have the right kind of content for the sorts of images that engaged him as a proto–Pop artist, but they would have had to be divested of the glitter of his shoe ads, and project an uninflected image, showing a shoe as it would appear in a simple advertisement, purged of its glamour, with its price printed next to it. It would have to have the down-to-earthness of the *Before and After* ad.

The deep psychological question is what explains why Warhol should have put aside the fey aesthetics of his early illustrated

books and chosen in their place the bare declarative aesthetic of the proletarian representations he began to favor. The cheap tabloid became for him a kind of quarry, and he began to paint two kinds of images: images from the comic pages, like Dick Tracy and Superman, Popeye, Nancy, or The Little King, and images from the advertising section, crude, direct logos in black and white, unambiguous and, one would say, without art.

Today, the comic panel strikes everyone as the archetypical Pop art image. There is, however, a deep difference between the comic images of Roy Lichtenstein, like Mickey Mouse or Blondie, and Warhol's rather more complex images. Lichtenstein's images reproduce, almost mechanically, the images as they appear in comic books or newspapers. He reproduces the means of reproduction, namely the dots of the Benday screen, so you get, in effect, hand-painted copies of images as they appear or would appear, on low-grade newsprint, using dots. A lot of Lichtenstein's images come from action comics, in which pilots zap enemy planes, and the comic word "Zap!" appears in the same frame. Or the inner thoughts of pretty girls appear written in thought balloons above their heads, connected to the thinkers by bubbles. Warhol's differ in various ways, but chiefly through the way in which words are blurred out by scumbled paint, so words or, better, fragments of words are visible only in part. And the viewer is very aware of the materiality of the paint, which has been allowed to drip. Lichtenstein applies paint the way the comic artist would, within carefully drawn boundaries. Warhol applies paint the way an Abstract

Expressionist artist would, allowing it to drip. "You can't do a painting without a drip," he told Ivan Karp, who was director of the Castelli Gallery. This is what I meant by saying that he used Abstract Expressionist gestural painting as protective coloration. The drips did not come from some inner conviction. They did not refer to that moment of trance when the Abstract Expressionist painter moved the paint around without tidying up. "The drip" in fact was felt in those years to be a discovery. It was a sign of authenticity. Not for Warhol. It was, for him, an affectation, a form of branding his work as *now*. What was special about these works was the effort to fuse mass art with high art—to paint the ultrafamiliar, like Popeye or Nancy, using paint like—or somewhat like—the Abstract Expressionists did. It was as if he were painting Abstract Expressionist cartoons. It was a stab at stylistic synthesis that did not go over with art world experts who felt strongly that Warhol was gifted.

One of these was certainly Ivan Karp. Warhol regularly visited Castelli's gallery, which was where the artists he most admired showed their work. It was the gallery that he would most wish to have been part of. What he discovered on one of his visits was that he was not alone—others were on a path very close to the one he was trying to follow. Karp showed him the work of Roy Lichtenstein, who had just joined the gallery.

Warhol was stunned that someone else was painting cartoons and advertising icons. Lichtenstein had painted an enlarged version of an icon showing, in color, a shouting girl in a bathing

suit, holding a beach ball. It was originally a boilerplate icon in advertisements for a resort, Mount Airy Lodge. Without modifying the image—he even used the Benday dots—Lichtenstein simply enlarged it to the size an Abstract Expressionist painting. To be significant in those years, a painting had to be big. Any reader of the *New York Post* would have recognized the image but would have been astonished to see it hanging in large format on someone's wall, without text. It would have been considered an aesthetic hybrid. Lichtenstein was painting to an exceedingly sophisticated audience. The fact is that, while hand-painted, the image had none of the Abstract Expressionist touches in paint handling that would have been noticed by anyone who bought the painting. Warhol told Ivan Karp that he had been doing the very same kind of painting, and invited him to visit his studio. Karp liked what Warhol was doing, but rightly objected to the messy paint.

Warhol's response to this criticism is deeply instructive in understanding how he made his moves forward. On this occasion, he enlisted the help of someone whose judgment he trusted. This was Emile de Antonio, a documentary filmmaker who, among other achievements, had made *Point of Order*—a film using footage from the McCarthy hearings in 1954. In the summer of 1960, de Antonio went to Warhol's town house to have drinks:

> [Andy] put two large paintings next to one another. Usually he showed me the work more casually, so I realized that this

was a presentation. He had painted two pictures of Coke bottles about six feet tall. One was just a pristine black-and-white Coke bottle. The other had a lot of Abstract Expressionist marks on it. I said "Come on, Andy, the abstract one is a piece of shit, the other one is remarkable. It's our society, it's who we are, it's absolutely beautiful and naked, and you ought to destroy the first one and show the other." [Bockris, 98]

It was almost a *Before and After* juxtaposition. What Warhol had been doing was adding marks that he thought were expected for a painting to be "who we are." De Antonio made him see that the direction was the reverse of what he had believed it should be. He had to remove all the mock expressionist markings. He ought, in truth, to have done in this respect what Lichtenstein intuited was right. I have written about this episode in an essay called "The Abstract Expressionist Coca Cola Bottle." The Coke bottle was, of course, an icon in its own right. If you want to paint it as an icon, you paint it as it is. It does not need any frills.

The way forward was clear. It was a mandate and a breakthrough. The mandate was: *paint what we are.* The breakthrough was the insight into what we are. We are the kind of people that are looking for the kind of happiness advertisements promise us that we can have, easily and cheaply. *Before and After* is like an X-ray of the American soul. Warhol began to paint the advertisements in which our deficiencies and hopes are portrayed. His

images after the change were vernacular, familiar, and anony-
mous, drawn from the back pages of blue-collar newspapers, the
cover pages of sensationalist tabloids, pulp comics, fan magazines,
junk mail, publicity glossies, boilerplate for throwaway advertise-
ments. It was as though he had received some commandment to
lead the lowest of the pictorial low into the precincts of high art.
There were no disclosures or confessions of what remains per-
haps the most mysterious transformation in the history of artistic
creativity. But that is not the whole of it. Warhol went from what
one of Henry James's characters describes as "a little artist man,"
on the fringe of a fringe of the art world, to the defining artist
of his era. That could not have happened had the world itself
not undergone a parallel change, through which the transformed
Warhol emerged as the artist it was waiting for.

Warhol's first exhibition after the conversion was in a space
that belonged by rights to the Warhol of shoes and pussycats: the
Fifty-seventh Street windows of Bonwit Teller. But the paintings
on display for one week only, in mid-April 1961, belong to his new
phase. There are five in all. *Advertisement* is based on a montage
of black-and-white newspaper ads: for hair tinting; for acquiring
strong arms and broad shoulders; for nose reshaping; for pros-
thetic aids for rupture; and ("No Finer Drink") Pepsi-Cola. In
1960, Pepsi-Cola had begun an advertising campaign in which
it proclaimed itself the drink "For those that think young," as if
it were the elixir of youth that Ponce de Leon had come to the
New World to discover. Bonwit's window also included *Before*

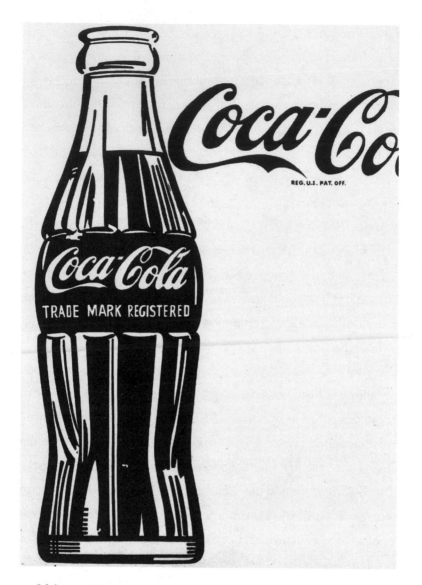

Of the two Coca-Cola bottles, done approximately two years apart, only the later one shows us what we are, according to Andy's mentor, Emile de Antonio. *(left)* Andy Warhol, *Large Coca-Cola*, c. 1962. Synthetic polymer paint on canvas, 85 × 57 in. © Copyright The Andy Warhol Foundation for the Visual Arts/ARS, NY; *(right)* Andy Warhol, *Coca-Cola*, 1961. Casein and crayon on linen, 69 ½ × 52 ¼ in. © The Andy Warhol Foundation for the Visual Arts/ARS, NY

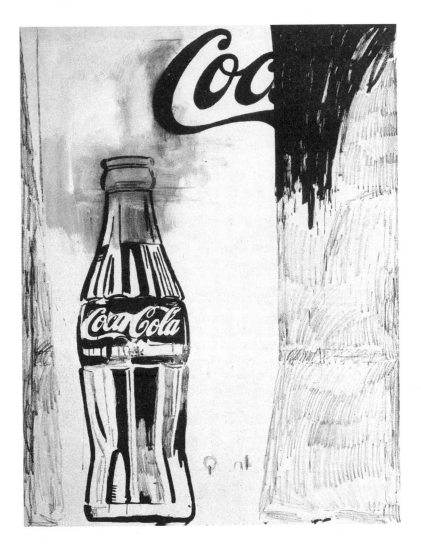

and After, advertising the nose you are ashamed of transformed into a nose to die for. The remaining paintings are of Superman, the Little King (on an easel), and Popeye. The ads reflect Warhol's personal preoccupations—impending baldness, an unattractive nose, a loose, unprepossessing body. But the placement of the original images—in back-page ad sections of the *National Enquirer* and comparable publications of mass consumption—testifies to the universality of such nagging self-dissatisfactions, and the inextinguishable human hope that there are easy ways to health, happiness, and how to "Make Him Want You." The paintings comment, almost philosophically, on the light summer frocks, displayed on mannequins placed before them. But the message is lightened by images of comic book personages with which everyone was familiar. Who, pausing to look at the display, would have predicted that *Advertisement* would find its way to Berlin's National Gallery by way of the museum at Monchengladbach and the Hamburger Bahnhof Museum for Contemporary Art? If such unpromising images can become fine art, there is comparable hope for the hardly more promising rest of us!

Years later, in the early 1980s, Warhol offered *Advertisement* to a Dr. Marx, a prominent German collector of contemporary art, through Heiner Bastien, a German curator who regarded Warhol as a great artist. According to Bastien, "We considered him generous to Marx because he pulled out all his old paintings. In the end he even pulled out his 'Advertisement,' because I said it would be wonderful to have this first painting in the collection.

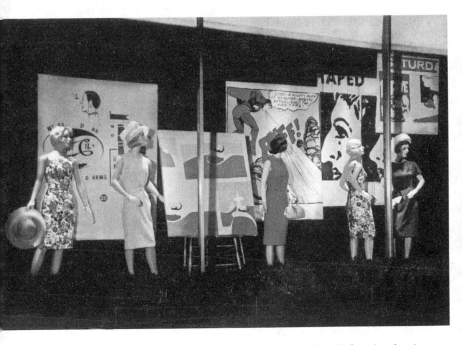

Andy's first show, held in the windows of Bonwit Teller in New York in April 1961,
reveals his feeling for the human condition. Photograph by Nathan Gluck

I don't think we are yet capable of understanding how radical
what Andy did really was. He has probably drawn a picture of
our times that reflects more about our time than any other art.
It seems as if he had some sort of instinctual understanding of
where our civilization is going to" (Bockris, 435).

What almost nobody in 1961 would have seen, had they passed
the window at Bonwit Teller, is that it was full of art. They thought
they were looking at women's wear, with some vernacular images
taken from the culture by some imaginative, in all likelihood
gay, window dresser. Who could have seen it as art in that year?

Not me, for sure. Not most of the art world, then still caught up with Abstract Expressionism. It would not have been until 1962 that I was aware of Pop from an illustration in *ARTnews*, showing what looked like a panel from an action comic, like *Steve Canyon*, showing a pilot and his girl kissing, and titled *The Kiss*. Lichtenstein would have seen it as art, as would Ivan Karp. So would de Antonio and Henry Geldzahler, the young curator of Modern American Art at the Metropolitan Museum. A few dealers, a few collectors.

What made it art, then? Warhol would certainly have been unable to explain. He affected a certain inarticulateness, stumbling and mumbling. It could not have lain in the difference in size between the advertisements as they appear in the newspapers and as they appear on the large panels Warhol used for the window at Bonwit Teller. One can imagine *Before and After* poster-size over the windows on subways or buses in New York, or even as rather dramatic billboards in Times Square. One of the Pop artists, James Rosenquist, actually worked for Artkraft Strauss sign corporation, painting giant billboards around the city. My view is that all the advertisements "appropriated"—the term was not used in the 1960s, and when it did become a form preempting images, as it did in the 1980s, its meaning was entirely different—have something in common. They all refer, to use the title of Grace Paley's collection of stories, to "the little disturbances of man." They refer to sagging stomachs, aching limbs, blemished skin, curly hair one wants to have straightened and

straight hair one wants to have curled, and the like. They offer help. But collectively they project an image of the human condition, and that is why they are art. The cartoons have another meaning. Their characters are American idols. Their virtues are beyond ours. Popeye's strength makes him the Hercules of his age. Nancy is wise beyond her years. And Superman is Superman, who has the attributes of a Bodhisattva — heeder of the cries of the world. They too promise help. They too promise hope. In the end, the window of Bonwit Teller was a showroom of the world of passersby. Everyone understood the images, because the world they projected was everyone's world. The world projected by Abstract Expressionism was the world of those who painted its paintings.

Warhol was not the first to raise, in its most radical form, the question of art. He redefined the form of the question. The new form did not ask, What is art? It asked this: What is the difference between two things, exactly alike, one of which is art and one of which is not? In its own way it is like a religious question. Jesus is at once a man and a god. We know what it is to be a man. It is to bleed and suffer, as Jesus did, or the customers whom the ads address. So what is the difference between a man that is and the man that is not a god? How would one tell the difference between *them?* That Jesus was human is the natural message of Christ's circumcision. It is the first sign of real blood being drawn. That he is God is the intended message of the halo he wears — a symbol that is read as an unmistakable outward mark of divinity.

Pop, Politics, and the Gap
Between Art and Life

There is no clear explanation of why a number of artists in and around New York City in the early 1960s, most of whom were known to one another distantly, if at all, should, each in his own way, begin to make art out of vernacular imagery—cartoon images from syndicated comic strips, or advertising logos from widely used consumer products, or publicity photographs of celebrities like movie stars, or pictures of things bound to be familiar to everyone in America, like hamburgers and Coca-Cola. In Spring 1960 Warhol bought a small drawing of a lightbulb by Jasper Johns at Leo Castelli's gallery. When shown Lichtenstein's large canvas that reproduced an advertisement for a Catskill resort, Warhol was mainly surprised that someone else was doing paintings of boilerplate advertisements, of the kind he was to display the following year in the Bonwit Teller window. As it happened,

he was the fourth artist Karp had visited within a few months who worked with such imagery. A constellation of artists, all producing paintings of a kind as new as their content was familiar, was less a movement than the surface manifestation of a cultural convulsion that would sooner or later transform the whole of life. "This is a tremor of the twentieth century," Karp thought to himself. "I felt it, and I knew it and I was awake to it."

Once it emerges that several artists were engaged in similar projects, wc explain it by saying that there was something in the air, and we no longer simply look for biographical explanations. Later in this chapter I shall write about Warhol's *Campbell's Soup Cans*, which have seemed to many to refer to his biography—that he ate that soup on a daily basis, for example. But in fact it would have seemed to Warhol that painting that kind of subject was a step toward becoming one of Castelli's artists, and showing in his gallery, which specialized in a certain kind of cutting edge art. Castelli had taken on Robert Rauschenberg and Jasper Johns—the artists Warhol admired most. He had just taken on Lichtenstein, whose art was close to what Warhol himself was producing, though Warhol had evidently been unaware of him. As Castelli's director, Karp was on the lookout for artists doing art of just this sort—he would have had no interest in Warhol if he were painting abstractions. And Karp knew ten or twelve collectors also interested in this type of art whom he could bring to Warhol's studio. Warhol did not yet have a gallery, but he belonged to an art world—a complex of dealers, writers, collec-

tors, and, of course, other artists, that was disposed to taking his work seriously. And that art world was poised to become the defining institution of the mid-1960s, built around the kind of art the media was bound to notice and write about. When that happened, Warhol was to become very famous indeed, even if much of the press was negative. He became, in brief, a sensation.

The term *Pop art* was first used in 1958 by Lawrence Alloway, a British critic, initially to designate American mass-media popular culture, Hollywood movies in particular. Alloway's contention was that these, like science fiction novels, were serious and worth studying, as much so as art films, high literature, and the products of elite culture in general. But by some sort of slippage, the term came exclusively to designate paintings—and sculptures—of things and images from commercial culture, or objects that everyone in the culture would recognize, without having to have their use or meaning explained. Warhol's first show in Bonwit's window was part of what would become an art movement the following year. Comic strip personages—Nancy, Superman, Popeye, the Little King, Dick Tracy—entered American artistic consciousness in the early 1960s in somewhat the same way that the imagery of Japanese prints entered advanced French artistic consciousness in the 1880s, with the difference that, however popular the prints were in Japan, they were exotic in France, while the American comics, with few exceptions, were dismissed as trash everywhere except in the art world, where they were exciting images because they implied a revolution in taste. These

images had ascended, through Warhol and Lichtenstein, into the space of high art. It was their popularity that recommended them to the Pop artists, which gave a kind of political edge to their promotion as art to be taken seriously.

How different this brash and irreverent art was from the culture of Abstract Expressionist painting, where meanings were personal and arcane, and expressed through pigment so energetically brushed, dripped, or splashed across large expanses of canvas that viewers were left with little to say in response except, "Wow!" Not that there was much to say in front of Pop art, since everyone knew what it was about. The question was what made the elements of everyday life all at once so compelling—what could the interest be in comic strip figures, or soup labels or ice-cream cones? Why would anyone want to paint, or make effigies, of them? Everyone in the culture was already so entirely literate in their meaning and rhetoric that the only question they seemed to raise was in what respect they could be considered art. From the perspective of the Abstract Expressionists, they could be so considered only by the "gum-chewing pinheaded" delinquents who, a noted critic declared, were beginning to populate the galleries, saying, presumably, "Wow," when they were not merely whistling through their teeth.

So it is not uncommon for commentators to explain this art simply as a predictable reaction against Abstract Expressionism. But there were many forms a reaction could take. Abstractionists could go back to nongestural abstract painting, as the so-called

Hard-Edged Abstractionists did. Or painters could go back to landscapes and still lifes. But there was something in-your-face about Pop art. Yes—everyone knew who Superman and Mickey Mouse were. But it took some special courage to accept a painting of either of them as high art. In my preface, I describe the shock with which I first saw, in 1962, a black-and-white reproduction of Roy Lichtenstein's painting *The Kiss* in *ARTnews*, the leading and most authoritative art publication of the time. It looked like a panel from *Terry and the Pirates* or *Steve Canyon*, but it was instead used to illustrate a review of Lichtenstein's first one-person show at Castelli's. I found it deeply disturbing, though I ultimately came to feel that, if that was art, anything could be art—*anything!* Years later, I heard Lichtenstein say that his aim was to overcome the distinction between high and low art by getting a painting of a comic strip panel into an art gallery. There was something revolutionary, something of what Nietzsche called the "transvaluation of values," in Lichtenstein's attitude. It condemned to irrelevance everything that belonged to art appreciation. Artists who made this turn were not simply reacting to Abstract Expressionism, they were revolutionizing the concept of art. They were pressing against a boundary. Imagine someone hanging a painting of a tin of shoeshine polish in his or her home, rendered literally, so one could not admire the brio of the brushwork—a painting that could have appeared in a magazine as an advertisement for shoe polish. What could that mean? It would mean at least that the owner of the painting had himself

crossed a boundary, and was making a statement about art, and about himself.

Revolutionary periods begin with testing artistic boundaries, and this testing then gets extended to social boundaries more central to life, until, by the end of that period, the whole of society has been transformed: think of Romanticism and the French Revolution, or of the Russian avant-garde in the years 1905 to 1915 and of Aleksandr Rodchenko's slogan "Art into life!" Strictly speaking, I think that the era of Modernism began to break up with the advent of Dada in 1915 as a revulsive reaction to World War I. It took place initially in Switzerland, which had remained neutral. The reigning idea was that artists were no longer prepared to make art for the pleasure of the ruling classes in Europe, whom they held responsible for the deaths, in the name of patriotism, of millions of young men and the devastation of civilian populations. The Dada artists felt powerless to do anything other than begin to make art that was disrespectful of the classes that had patronized the arts, and to mock the very idea of the Great Artist, whose work brought glory and edification to those in power. The emblematic Dada work was Marcel Duchamp's L.H.O.O.Q.—a mild French obscenity when the letters are pronounced—printed across the bottom of a postcard of the *Mona Lisa*, on which the artist drew a moustache. Duchamp was the central figure of provocative disrespect that bridged the Dada revolt and detonated the attack against boundaries that defined Modernism. The culminating Modernist aesthetic was po-

litical. It consisted of the great monolithic states, Nazi Germany and Fascist Italy in particular, the regimentation of life, and the glorification of war. Abstract Expressionist paintings were very far from the political vision of these states and their concept of power. They are, indeed, celebratory of personal privacy. But in their scale and power they are also celebratory of the spirit of heroism, which Dada began its adventure by mocking. Abstract Expressionism was the last great artistic expression of the Modernist spirit.

There were certain centers in America in which artistic innovation of a certain kind was encouraged in the 1950s: Black Mountain College, where Robert Rauschenberg and Cy Twombly were students and John Cage was a teacher; the seminar in Zen Buddhism taught by D. T. Suzuki at Columbia University, attended especially by avant-garde composers like John Cage and Morton Feldman, and by artists like Philip Guston and Agnes Martin; and then Cage's own course in experimental composition at the New School for Social Research, out of which Fluxus, a radical art and music movement, was formed, committing itself to "overcoming the gap between art and life." The Fluxus slogan echoed Rodchenko's "Art into life" agenda, and found expression in Robert Rauschenberg's statement in the catalog for the 1959 Museum of Modern Art exhibition *Sixteen Americans*, in which he wrote: "Painting relates both to art and life. I try to act in the gap between the two. There is no poor subject. A pair of socks is no less suitable to make a painting than wood, nails, turpen-

tine, oil, and fabric." Rauschenberg should have used the word "art" rather than "painting." He was giving himself license to use anything he wanted to use for making a work of art. By the early 1960s this inclusionary impulse extended itself to dance. A dance movement could consist of sitting in a chair, eating a sandwich, or ironing a skirt. The question "What is dance?" joined the questions "What is music?" and "What is painting?" Where and how was the line between art and life to be drawn? As the 1960s progressed, the testing of cultural boundaries became the defining project of the decade.

Pop art was part of the cracking of the spirit of Modernism, and the beginning of the Postmodern era in which we live. In December of 1961, Claes Oldenburg turned a downtown store on the East Side of Manhattan into a place in which he would sell his sculptures, which were made of plaster, chicken wire, and cloth, painted over with household enamel to form crude representations of everyday things—dresses, tights, panties, cake, soda cans, pie, hamburgers, automobile tires. It was more like a general store than an art gallery, and Oldenburg indeed called it "The Store," as if the sales place and the items for sale constituted an artwork. Oldenburg was the storekeeper who wrote out sales slips. The merchandise was displayed in the store window. People bought art from it the way they bought groceries from grocery stores, or dry goods from dry goods stores. It was obviously very different from the smart display windows of Bonwit Teller, in which Warhol had displayed his art in April. In a sense,

Oldenburg's was an act of institutional critique. It was a critique of the air of preciosity art galleries and museums created to reflect on the preciousness of the art they showed. It too was a way of overcoming the gap between art and life. But it was also a way of becoming known very quickly, if your work attracted media attention.

Since at least the Armory show of 1913 (in which Duchamp's *Nude Descending a Staircase* was the paradigm of avant-garde art) the doings of avant-garde artists made good copy. What caused Warhol to begin to paint the advertisements and cartoons he installed for a brief time in the Bonwit Teller window is one of the deep mysteries of his biography. But there is no such mystery regarding his decision to paint cans of Campbell's soup. He wanted to become very famous very quickly, and nothing could achieve that for him that did not attract media attention. He was a Pop artist before the meaning of the term was stabilized, but Pop in 1962 was what caused people to talk.

There are various stories about where Warhol got the idea for the *Campbell's Soup Cans*, but it is worth examining at least one of them—an encounter with an interior designer, Muriel Latow, whom he begged for an idea. There are enough such stories to suggest that this was a regular pattern with Warhol. He got his ideas from others much of the time. In a 1970 conversation with Gerard Malanga, his assistant and sidekick, Warhol said, "I always get my ideas from people. Sometimes I don't change the idea. Or sometimes I don't use an idea right away, but may remem-

ber it and use for something later on. I love ideas." Warhol told Latow he needed something "that would have a lot of impact, that would be different from Lichtenstein and Rosenquist, that will be very personal, that won't look like I'm doing exactly what they're doing." Latow told him that he should paint something that "everybody sees every day, that everybody recognizes . . . like a can of soup." The form of Warhol's question ruled out a lot of possibilities. He was not interested in being told to do a nice, cheery abstraction, or Manhattan by moonlight, or a pretty girl reading a letter by the window. It had to be something from the common culture that hadn't already been done by someone else. It had to be something people would talk about without having seen it. How many people have actually seen the diamond encrusted skull that Damien Hirst is alleged to have sold for a hundred million dollars? But that doesn't keep them from wondering how much it is really worth, who would buy it, what it meant, why anyone would do it.

It is one thing to be told to paint soup cans, another to determine how the painting or paintings should look. Warhol's response was far more than simply a painting of a soup can. It was an eight-by-four grid, consisting of each of the thirty-two varieties of Campbell's soups produced at the time—like an installation of portraits of notable personages. Warhol put into effect what he had learned from Emile de Antonio: the paintings had nothing painterly about them, but looked as if they were mechanically reproduced, as indeed they were, since Warhol used a

silk-screen process to achieve a look of perfect uniformity. In any case, the array is severely frontal, like Byzantine portraits, and the four rows of eight paintings each were like an up-to-date iconostasis—a wall of icons such as the one in the Orthodox church in which Andy's mother, Julia Warhola, worshipped in Pittsburgh when he was growing up. Or a regularly stacked set of supermarket shelves, which embodied an aesthetic that greatly engaged Warhol. None of the other Pop artists used this sort of format, in which essentially the same image was repeated and repeated. Even when he came to do portraits, later in his career, Warhol favored using a block of the same picture of the same person in different colors. The *Campbell's Soup Cans* were portraits, in that each contained a different variety of soup, the name of which was printed on its label. Repetition came to be one of the master elements in what could be called the Warhol Aesthetic.

There is a question of genre that applies to almost everything Warhol did at the time—whether there were thirty-two paintings, or one installation consisting of thirty-two parts. My sense is that he had in mind the entire array as a single work. They were projected and then touched in by hand. He could have turned out as many of each variety as he wished. But he did only one of each, suggesting that he was bent on making a wall of soup cans, consisting of thirty-two unique units. When the work was exhibited at the Ferus Gallery in Los Angeles in July 1962, however, they were displayed in a single line, placed on a narrow shelf around the gallery. And they were evidently sold one at a time, for $100

each. But the dealer, Irving Blum, increasingly felt that the paintings belonged together, "as a set," as he put it. Warhol was pleased by Blum's decision, since they were "conceived as a series." Blum was able to buy back the ones he had sold, and Warhol set a price of $1,000 for what was now recognized as a single work. Blum sent him $100 a month until it was paid up. And they began to be exhibited as a single unit, a matrix.

The *Campbell's Soup Cans* were already famous before anyone other than those who dropped by Warhol's studio had really seen them. They were described in *Time* magazine in May 1962. This was publicity of a kind that registered these works as a cultural rather than merely an art world event—that whatever the art world might have thought, Warhol was on his way to being an American icon. It hardly mattered whether the publicity was good or bad: the art world thrived on controversy. Warhol came to the attention of Eleanor Ward, who owned the Stable Gallery, which in fact was originally housed in a former stable on West Fifty-eighth Street near Seventh Avenue. She asked Warhol's mentor, Emile de Antonio, to take her to Warhol's studio. She made him a deal; if Andy would paint a portrait of her lucky two-dollar bill, she would give him a show in November of that year. (In addition to soup cans, Muriel Latow had suggested that Warhol paint pictures of money.) Ward had an eye for serious art. Rauschenberg and Twombly were two of her artists. She had shown Robert Motherwell, and had just taken on Marisol and Robert Indiana. But more than any of them, Warhol's *Soup Cans*

raised the question of what was art in a way that could not be resisted.

Everyone's conception of art was of something spiritually rich that belonged in gold frames and that hung on museum walls, or in the mansions of the wealthy. In his biography of Warhol, Victor Bockris interviewed one of Warhol's earlier friends, Charles Lisanby, who flatly turned down the offer of one of his portraits of Marilyn Monroe. "Just tell me in your heart of hearts you know it isn't art," he said to Warhol. "He would never have admitted it, but I knew he knew that it wasn't" (p. 157). It is hard to know what Warhol thought of such questions, but I feel that he knew that he had taken art to a new place. As a teenager, I haunted the galleries of the Detroit Institute of Art, in which there were shiny oil paintings of saints, of princes on horseback, of ladies in long satin skirts reading love letters. To imagine that a flat and faithful image of a can of Campbell's soup would have been a work of art, fit to hang in their company, would have been unthinkable. Other than the fact that it was a painted picture, it would seem to have nothing in common with what anyone thought art was. It was part of life, but hardly a piece of what anyone would have recognized as art. At the very least a philosophical definition of art would have to apply to it as well as to El Greco's saints, or Terborch's Dutch beauties, or Velázquez's royal personages. If a definition was to do that, it would have to be emptied of everything that applied to these masterpieces but did not apply to the painting of the soup can. All at once, the

Campbell's soup can invalidated as insufficiently general the entire canon of philosophical aesthetics, and at the same moment defined its time. It was, as de Antonio said, who we are.

Warhol painted Campbell's soup cans throughout his life. After the Ferus Gallery soup cans, there were paintings of a hundred, and even two hundred, *Campbell's Soup Cans.* Then there were paintings of Campbell's soup cans in which the cans were undergoing some kind of martyrdom—being pierced with a can opener, or crushed, or flayed by having the label torn off. These belong in spirit with the various paintings of human disasters that he was shortly to turn to—car crashes, airplane crashes, and the like. The formats he discovered for showing the cans feel almost like formats for religious painting—choruses, assemblies, iconostases, where the cans were understood as vessels for our daily soup. There was a steaming bowl of Campbell's soup leaning against the far wall of his studio when he left it for the last time, when he went to the hospital for the operation that was to kill him in 1987. It is next to a double Jesus, from the *Last Supper* variations he did in his last years. It really did meet his demand that, whatever "idea" Latow was to give him, it had to be personal. What he admired about commercial culture was the uniformity and predictability of everyday manufactured food. One can of Campbell's tomato soup is like every other can. No matter who you are, you cannot get a better can of soup than the next person. Wittgenstein said that he did not care what he ate as along as it was always the same. The repetition of instantly rec-

ognized food containers—Campbell's cans, Coca-Cola bottles—was an emblem of political equality. It was not simply a formal device of advanced painting.

In November 1962 Warhol's show opened at the Stable Gallery, which had since relocated to an elegant town house on East Seventy-fourth Street. A week earlier, three of his works appeared in a show called "The New Realists" at the Sidney Janis Gallery on Fifty-seventh Street, curated by the French critic Pierre Restany, who was associated with the *Nouveau Realiste* movement in France. The Janis show may have appeared to be an effort to absorb Pop into the European movement, and at the same time declare that the Abstract Expressionist movement had come to an end, since Janis's gallery had represented several of its leading figures. To turn its space over to the Pop and the New Realists seemed a betrayal of the values of the New York School in favor of the values of the "gum-chewing, pinheaded delinquents." Several of the older artists resigned in protest.

Certainly a line was being drawn between two periods of artistic production in New York, but even more, though this was less evident at the time, between two periods of art history. The 1960s effectively saw the end of Modernism and the beginning of an entirely new era, which Pop exemplified. But Pop was also too American in spirit to be easily absorbed into a single movement with the *Nouveaux Realistes*, which was essentially an expression of European values. The robust Americanism of Pop was perhaps accentuated by the end of the Cuban missile crisis on October 26

of that year. The sudden lifting of the threat to the entire form of life the Pop artists celebrated must have added a certain luminosity to such innocent artifacts of the American soul as Campbell's soup and Coca-Cola. I remember, as a Fulbright student, sitting in an audience addressed by Janet Flanner, the expatriate *New Yorker* writer, who told us that the stomach is the most patriotic of organs, that there were times when the craving for certain foods that could not be satisfied in Paris was overwhelming.

There were eighteen rather heterogeneous works in Warhol's first Stable show: three so-called serial works of one hundred soup cans, one hundred Coca-Cola bottles, and one hundred dollar bills, as well as *Red Elvis*—a serial array of thirty-six Elvis heads. There were two paintings with Marilyn Monroe as subject, one of which, consisting as it did of fifty Marilyn heads, could have been counted as a serial painting, as could a silk-screen painting of the baseball player Roger Maris swinging a bat, over and over and over, in front of a catcher, like a recurrent memory. Then there was *Dance Diagram*, a large black-and-white painting of where to put one's left and right foot, together with the connecting lines to be following in executing a step; and *Do It Yourself (Flowers)*, a brilliant "painting by the numbers" painting. There were no comic images of the sort included in the Bonwit Teller show, Warhol having left that genre of Pop to Roy Lichtenstein. Finally, there was the first of Warhol's Death and Disaster paintings, *127 Die*. A reviewer would have had a hard time putting this

all together as a consistent oeuvre. But it made clear that Warhol was more than the painter of soup cans.

Dance Diagram and *Do It Yourself (Flowers)* belong with the grainy advertisements of the Bonwit Teller window display, if we think of the latter as a kind of portrait of everyman and everywoman, with their inventories of minor aches and pains, and the cosmetic blemishes that make them, in at least their own minds, unattractive, and hence unlovable and lonely. Learning to dance presents itself as a way of overcoming the loneliness: one can hold a partner while the music plays, and feel the other's warmth. Learning to paint by buying a kit and filling in the numbered areas on a canvas board with pigment is a pathetic effort at self-improvement by acquiring an "accomplishment" that involves no talent whatsoever. It only underscores the distance between one's life and that of the celebrities that makes one feel inferior. But even the celebrities are not that happy. Marilyn Monroe committed suicide the day that Warhol's show at the Ferus Gallery closed. Warhol painted her beautiful head as if it were the head of a saint on a field of gold leaf in a religious icon. She was Saint Marilyn of the Sorrows. Her beauty was a mask. Warhol's skills as a commercial artist stood him in good stead when he began to execute Marilyn Monroe paintings. He drew a frame around her head in a publicity photograph for the film *Niagara* and had it made into a silk screen. This, in effect, made her face into a mask, which he could reproduce over and over again. In fact, Warhol did twenty-four *Marilyn* paintings, the most spectacular of which

was *Marilyn Diptych*, which was included in his first Stable Gallery show.

The colors in *Marilyn Diptych* were garish—chrome yellow hair, chartreuse eye shadow, smeary red lipstick. There were two sets of twenty-five Marilyns, colored on the left, black and white on the right. The colored ones are fairly uniform, even if off-register. The black-and-white ones show a certain variation. In the second row from the left, for example, the screen gets clogged with the black ink, as if a shadow had fallen over the star's face. Then the features get paler and paler until, in the upper right corner, the face feels as if it is fading away from the world as we read across the diptych. It is like a graphic representation of Marilyn dying, without the smile leaving her face. In this respect the fifty faces of Marilyn Monroe is very different from the array of thirty-two *Campbell's Soup Cans*, which are uniformly bright. There is no internal transformation. In *Marilyn Diptych* there is repetition, but it is a transformative repetition, in which the accidentalities of the silk-screen medium are allowed to remain, like the honks and squawks of a saxophone solo, in performances by John Coltrane.

The one anomalous work was *129 Die*. It was the front-page photograph of a jet crash in the *New York Mirror* for June 4, 1962. Henry Geldzahler, the curator of contemporary art at the Metropolitan Museum, brought it to Warhol, saying, "It's enough life. It's time for a little death." He wanted Warhol to change from the celebrator of consumption to something deeper and more serious.

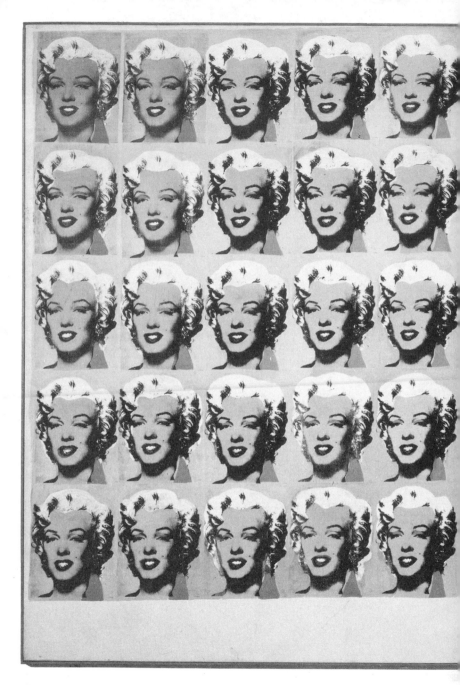

Dying in America. Andy Warhol, *Marilyn Diptych*, 1962. Synthetic polymer paint and silk-screen ink on canvas, 82 × 57 in. (205.4 × 144.8 cm). Tate, London/Art Resource, NY

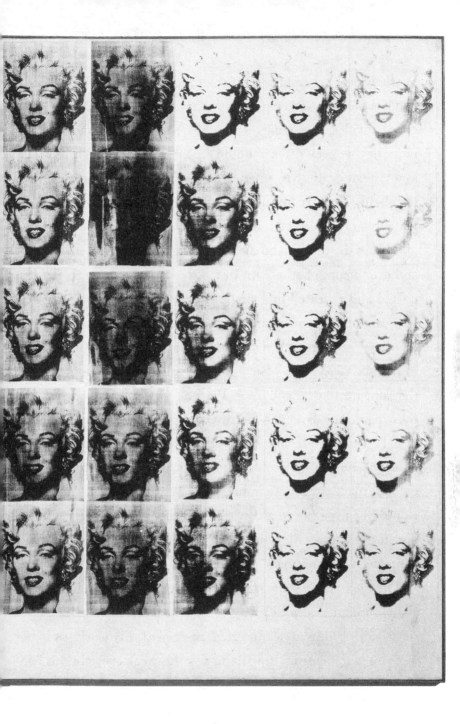

Warhol was to spend much of the following year making Death and Disaster silk-screen paintings: car crashes, plane crashes, race riots, suicides, poisonings—the disasters we see on the evening news, or that get written about in the tabloids and then forgotten, as if violent deaths happened to others, to people we know nothing about. They are like illustrations to Marcel Duchamp's mock epitaph—*D'ailleurs, c'est toujours les autres qui meurent*—"Anyway, it's always the others who die." Like the batter who dreams, over and over again, of a base hit or a strikeout, the disasters are repeated and repeated in a single frame, as if to dull the horror. You cannot die more than once—"After the first death there is no other," as the poet Dylan Thomas wrote—though Warhol did in fact die twice. But what does it mean, showing people dying the same death over and over? Warhol used decorator colors for these paintings, lavender and rose and orange and mint-green— as if he were producing wallpaper. Sometimes he would pair a disaster painting with a blank monochrome canvas in the same color. It made for a more impressive work than the disaster taken alone. But it points to a contrast as well, between the world of disaster and devastation and the void—the world emptied of incident, lavender emptiness.

The 1962 Stable show was a huge success, critically and financially, though Warhol's prices were unusually modest. But in a way Warhol himself was carried along with his work, as if he were inseparable from it, with his wig, his weak eyesight, his bad complexion, his loopy, ill-defined musculature. Who, unless they

knew Lichtenstein or Oldenburg or Wesselman or Rosenquist personally, had any idea of what they actually looked like as men? But Andy became as recognizable as Charlie Chaplin or Mickey Mouse. He became a public personality. With the first Stable show Warhol became Andy, the Pop artist—an icon, identified with his bafflingly obvious work, and with the world in which Americans lived. He was the one that took that world and turned it into art that everyone felt they understood. Much of the publicity was negative, but there was a lot of it, and it didn't matter what it said.

One the best critics of the time responded to what the negativity left untouched. Michael Fried, cultivated and sophisticated as few journalistic critics, captured the great truths of the Stable shows: "Of all the painters working today in the service—or thrall—of a popular iconograph, Andy Warhol is probably the most single-minded and the most spectacular. At his strongest— and I take this to be the Marilyn Monroe paintings—Warhol has a painterly competence, a sure instinct for vulgarity (as in his choice of colors) and a feeling for what is truly human and pathetic in one of the exemplary myths of our time. That I for one find moving."

The tragedy of the commonplace—"beauty falls from air, queens have died young and fair"—is as true of New York and Los Angeles in the 1960s as it was of Paris and Lombardy at the time of the Renaissance. No one standing in front of *Marilyn* could say—how cheap, how empty. Warhol, in giving us our

world transfigured into art, transfigured us and himself in the process. Even if the Death and Disaster paintings did not sell, even if Pop's days were numbered, ours was becoming the Age of Warhol. An Age is defined in terms of its art. Art before Andy was radically different from the art that came after him, and through him.

The Brillo Box

Because of the success of his first show at the Stable Gallery, Andy attained a degree of celebrity unshared by the other artists in the Pop movement: it in fact outlasted the movement itself, which was as much a cultural craze as an art movement, based on brashness and novelty. His productive career took a direction very different from that of any of his peers. It was not the typical career of the Artist in his Studio, producing a body of work to be shown at regular intervals at a gallery, harvesting critical reviews and sales to important collectors. More than any artist of comparable importance, Andy intuited the great changes that made the 1960s the "Sixties," and helped shape the era he lived through, so that his art both became part of his times and transcended them. He invented, one might say, an entirely new kind of life for an artist to lead, involving music, style, sex, language, film,

and drugs, as well as art. But beyond even that, he changed the concept of art itself, so that his work induced a transformation in art's philosophy so deep that it was no longer possible to think of art in the same way that it had been thought of even a few years before him. He induced, one might say, a deep discontinuity into the history of art by removing from the way art was conceived most of what everyone thought belonged to its essence. Picasso, it must be said, was the most important artist of the first half of the twentieth century, inasmuch as he revolutionized painting and sculpture in deep and liberating ways. Warhol revolutionized art as such. His decisions were always surprising, and if they did not especially make his work popular, they seem, in retrospect, to have been precisely in harmony with the spirit of his era. Which makes it natural to think of ours as the Age of Warhol, to the degree that he set his stamp on what was allowable.

This conceptual reconfiguration of art began in early 1964 with a body of work quite unlike anything done before, when he moved his place of operation from a not-entirely-functional firehouse to a new space—a former factory at 231 East Forty-seventh Street in Manhattan, which indeed became known as "The Factory." The Factory evolved into something that was far more than a place for making art. It became a place where a certain kind of Sixties person was able to live a certain kind of Sixties life. It became, to use a vision projected in the writing of Rabelais, a sort of Abbey de Thélème, the motto of which was *Fais ce que tu voudras*—"Do as you wish." In Rabelais's Abbey, beauti-

ful couples followed the paths of sexual love wherever they led. The people who found their way to the Factory were typically beautiful but also lost, so that what they possessed was at most a kind of "piss glamour," to use an epithet once bestowed on Edie Sedgwick, Warhol's paradigm Superstar. In many cases they were destroyed by the Factory's permissiveness, whether of sex or substance. At the center of it all was Warhol, himself anything but beautiful, whose personality was that of a workaholic, producing art, setting the direction, and using the misfits that found their way to the Factory as sources of inspiration in exchange for being allowed to watch them do what they wanted to do. They called him Andy to his face but "Drella" behind his back—a combination of Dracula and Cinderella, until that term almost became his Factory name.

Initially, however, the Factory was defined not only by work, but by a kind of repetitive, factory-like labor, where Andy and a few assistants produced, in large but manageable numbers, a variety of three-dimensional objects that he referred to as sculptures, but that looked like industrial products—like objects that would normally be produced only for some utilitarian purpose by machines designed to produce them: impersonal, mechanically achieved objects with no aesthetic aura. When we think of sculpture, we think of Michelangelo, Canova, Rodin, Brancusi, or Noguchi, creating unique objects of beauty and meaning. It would, before Warhol, never have occurred to someone to create, as sculpture, something that looked like a cardboard carton

for shipping packages of consumer goods. Not only did Warhol produce exactly that—he did so through a process that in a way parodied mass production. His sculpture looked like the kinds of boxes, ordinarily made of corrugated cardboard, in which cans of food or cartons of cleaning supplies were shipped from the factories where they were made to the places where they were sold to consumers, such as supermarkets. Cardboard cartons, bearing brand names and logos, were entirely familiar items in everyday American life, used, once they were emptied, for storing and shipping things, and for any number of other household functions, their logos continuing to advertise the products they once contained, things that were themselves familiar parts of domestic life. But Warhol was less interested in them for their everydayness than he was in the aesthetics of the unopened shipping cartons, stacked in regimented piles, in the stockrooms of supermarkets, as far as the eye could see. He wanted, in the words of his assistant, Gerard Malanga, "to become totally mechanical in his work the way a packaging factory would normally silkscreen information onto cardboard boxes" (Malanga, *Archiving Andy Warhol*, 34). And for that he needed not so much a studio as a factory. Hence the name of his workplace.

Malanga is our primary source for how these boxes were produced, and for what Andy's vision was in organizing the Factory along industrial lines, paradoxically when one considers that the human beings who came to be parts of the Factory's population were anything but robots. "Andy was fascinated by the shelves

of foodstuffs in supermarkets and the repetitive, machine-like effect they create. . . . He wanted to duplicate the effect but soon discovered that the cardboard surface was not feasible" (Malanga, 94). Since the effect in question *is* usually achieved by the stacking of cardboard cartons in warehouses and storerooms, it is difficult to see what was wrong with cardboard, which Warhol could have used with far less effort simply by purchasing cardboard cartons from the companies that manufactured them, treating them as readymades. It was as though reality was not machine-like enough to accommodate his vision. Equally important, work was so central to his conception of art that the idea of using as art something that was not produced by work would have held no interest for him.

The Dadaist Marcel Duchamp, with whom Warhol is often compared, had introduced the concept of the readymade into art in a set of works "created" in the years 1913–17. His most famous readymade was a urinal he allegedly purchased from a plumbing supply store—a white porcelain vessel manufactured by the Mott Iron Works, which he saw displayed in a plumbing supply store window. He added a signature—not his own but rather "R. Mutt," presumably a near pun on "Mott"—and a date, and made history by attempting to enter it in an exhibition of the Society of Independent Artists, which was supposed to have no jury and no prizes. It was in fact rejected by the hanging committee, which argued that any piece of art would be hung as a matter of course, the problem being that this was not art. At a stroke, the question

What is art? was raised in a new form. The original Dadaists, who fled World War I by settling in Zurich, had decided, in 1915, in protest against the classes responsible for the Great War, to refuse to make art that was beautiful at a time when it was widely believed that beauty was the whole point of art. That was the first skirmish in the anti-aestheticism that became such an important strand in modern art. If art did not need to be beautiful, what did it need to be in order to be art? Warhol, in my view, took the question of what was art to the next stage. If we think of the history of Modernism as a struggle on the part of art to bring to conscious awareness an understanding of what it—art—is, then Warhol's "grocery boxes" are among the most important of all Modernist works. He in effect brought Modernism to an end by showing how the philosophical question of What is art? is to be answered.

In an exhibition of Warhol's work installed in 1968 at the Moderna Museet in Stockholm, Warhol ordered five hundred cardboard Brillo cartons from the Brillo company, which were used to create the atmosphere of a stockroom, but which were in no sense considered works of art, either in their own right or in the aggregate. By 1968, the grocery boxes, and especially the *Brillo Boxes*, were, together with the *Campbell's Soup Can* paintings, his iconic work, so there had to be some grocery boxes, and ideally some *Brillo Boxes*, in any true retrospective exhibition of his work. In fact, Warhol had arranged for the curator Pontus Hulten to have a large number of *Brillo Boxes* fabricated specifically for the

Stockholm show, which he intended to then donate to the Moderna Museet when the exhibition had finished its final venue. He did that for his 1970 show at the Pasadena Art Museum in California. But for mysterious reasons, Hulten did no such thing. There may have been a few of the 1964 *Brillo Boxes*, but mostly there were the cardboard boxes, which were not really artworks, and which were in fact without value. But in 1990, after Warhol's death, Hulten did have about 120 Brillo boxes fabricated, which he then certified as made in 1968, and sold them for huge amounts of money. But they were counterfeit. By contrast, the Appropriation artist Mike Bidlo also made a number of "Brillo boxes" in the 1990s, which he signed with his own name and titled *Not Andy Warhol*. Bidlo's boxes, as part of the Appropriationist movement, are works of art in their own right, raising questions of their own, but they are no more counterfeit than Warhol's boxes were. But it would be a digression to address that matter here, so I return to the narrative of the "Factory made" grocery boxes of 1964.

Since the cardboard cartons actually used by the Brillo company—and facsimile cartons by other companies that were also created for Warhol's 1964 show—were not capable of achieving the visual effect at which he aimed, Warhol decided that the grocery boxes had to be made of wood, and fabricated by wood craftsmen, who were trained in cutting and fitting pieces of wood together according to specifications given them. The craftwork was not part of the artistic process, any more than it was part of the art of painting that the artist should actually make the paint

he or she used. Malanga located a woodworking shop on East Seventieth Street and placed an order for several hundred wooden boxes in various sizes, which were delivered to the Factory on January 28, 1964. It was becoming, in the mid-1960s, a commonplace practice to rely on craftspersons when an artist lacked the skills needed to produce desired aesthetic effects. Donald Judd, the Minimalist sculptor, for example, used the services of a machine shop to fabricate the metal boxes he used as sculptures, since he could not achieve by hand the sharp edges and corners that constitute aesthetic features of the perfectly matched metal units—that composed the "specific objects," as he called them—that Judd became known for. In the 1990s Jeff Koons routinely sent his pieces out to artisans in ceramic or in metal, knowing that he did not have the skills required to make them himself. He was not an artisan but an artist. The artist had the ideas: there was no reason why he had to make the material objects that *embodied* those ideas. Robert Therrien's sculpture consists of ordinary household items fabricated on a scale of about three-and-a-half to one: huge pots, pans, folding chairs, folding metal bridge tables. Some of his works consist of stacks of pans or dishes. It would be a waste of his talent, even if it were possible for him to make these objects by hand. Some artists—Damien Hirst comes specifically to mind—consign their paintings to others to paint, so that a show of Hirst's paintings sometimes looks like a group show. Since Duchamp—certainly since Cage—chance was built into artistic production, so that it is thinkable that an artist could

pick the name of a painter out of a list at random, and then exhibit the painting, whatever its style or content, as his. In any case it is no longer part of the concept of original art that it actually be made by the artist who takes credit for it. It was enough that he conceived the idea that it exemplified. Parenthetically, no one else, so far as I know, took credit for the idea of making grocery boxes the way, for example, they did for the idea of painting the soup cans or the Death and Disaster paintings. It was an idea that in its realization incorporated repetition and the effect of being machine-made, both of which were central to Warhol's aesthetic. And their production fit perfectly with Andy's thought that he wanted to be a machine. "I like things to be exactly the same over and over again."

There is not a lot of difference, in one respect, between selecting a readymade, like a snow shovel or a metal grooming comb—or a bottle rack or a plumbing fixture—and having something fabricated. In both cases the object is produced by someone else, the artist himself taking credit for the fact that it is art. On the other hand, not just any object can be a readymade. In a talk Duchamp gave at the Museum of Modern Art in 1961, he said: "The choice of these 'readymades' was never dictated by aesthetic delectation. This choice was based on a reaction of visual indifference with at the same time a total absence of good or bad taste . . . in fact a complete anesthesia" (Duchamp, "A Propos of 'Readymades,'" 21). Duchamp's agenda was polemical, as the word "taste" implies. In classical aesthetics, taste, and, in particu-

lar, good taste, played a crucial role: it was connected with plea-sure. And in the 1950s and the early 1960s, visual pleasure—what Duchamp scorned as "the retinal"—was what art was supposed to be about. When the critic Pierre Cabanne asked Duchamp where his antiretinal attitude came from, Duchamp replied, "From too great an importance given to the retinal. Since Courbet, it's been believed that painting is addressed to the retina. That was everyone's error. The retinal shudder! Before, painting had other functions: it could be religious, philosophical, moral. . . . Our whole century is completely retinal. . . . It's absolutely ridiculous. It has to change" (Cabanne, 43).

In a certain sense, Warhol was a follower of Duchamp. When he asked an assistant, Nathan Gluck, to bring some cardboard boxes from the supermarket near his house, he was disappointed when Gluck brought back boxes with elegant designs. Andy wanted something more common. Malanga intuited his needs: "The brand names chosen consisted of two versions of Brillo, Heinz Tomato Ketchup, Kellogg's Corn Flakes, and Mott's Apple Juice." (He left out Delmonte Peach Halves and Camp-bell's Tomato Juice.) But Warhol was not anti-aesthetic in quite the way that Duchamp was. Duchamp was trying to liberate art from having to please the eye. He was interested in an intellec-tual art. Warhol's motives were more political. Andy really cele-brated ordinary American life. He really liked the fact that what Americans eat is always the same and tastes predictably the same. "What's great about this country is that America started the tra-

dition where the richest consumers buy essentially the same thing as the poorest. You can be watching TV and see Coca Cola, and you can know that the President drinks Coke, Liz Taylor drinks Coke, and just think, you can drink Coke too. A Coke is a Coke and no amount of money can get you a better Coke than the bum on the corner is drinking. All the Cokes are the same and all the Cokes are good. Liz Taylor knows it, the President knows it, the bum knows it, and you know it" (*Andy Warhol: A Retrospective*, 458).

Andy's art is, in a way, a celebration as art of what every American knows. Who knows but what his boxes were not inspired by the famous protest song "Little Boxes," written by Malvina Reynolds in 1962 and made popular by the folksinger Pete Seeger in 1963? It was a satire on the proliferation of housing developments in which each unit looked the same as every other unit in the development. Unquestionably, McDonald's is the paradigm of universal sameness in food the world over, singled out wherever globalism is protested. But as we know, Andy liked everything to be the same.

He thought that that was what was great about America. And after all, he grew up in squalor, in a depressed neighborhood in Pittsburgh. He once said that the house he grew up in "was the worst place I have ever been in my life" (Watson, 5). The "little boxes" of Daly City, California, would have been palaces in comparison to the slum he knew as a child in Pittsburgh. The warm, tasty, nourishing food from the supermarkets was a daily treat.

Against the grinding poverty in which he grew up, the storm doors and refrigerators he painted were warmth and satisfaction embodied, just as blankets and fat were the antidotes to cold and hunger in the symbolic system of Josef Beuys. "Ticky-tacky," applied to the little boxes by those protesting the spiritual poverty of suburban life, betrayed the fact that those who used the expression had lost sight of the fundamental needs that the victims of hunger and cold would give their lives for. "I adore America," Warhol once said, "and these are some comments on it. My *Storm Door*, 1960, is a statement of the harsh impersonal products and brash material objects on which America is built today. It is a projection of everything that can be bought and sold, the practical but impermanent symbols that sustain us" (*Andy Warhol: A Retrospective*, 458). And in an interview on Pop art, he said: "The Pop artists did images that anybody walking down Broadway could recognize in a split second—comics, picnic tables, men's trousers, celebrities, shower curtains, refrigerators, Coke bottles—all the great modern things that the Abstract Expressionists tried so hard not to notice at all" (*Andy Warhol: A Retrospective*, 461). But who before the Pop artist would have thought to make sculptures out of grocery boxes?

In any case, now that we understand why the boxes had to be made of wood joined together by cabinetmakers, let's return to the factory-like way in which the grocery boxes were made. Once the boxes were delivered, Andy and his assistants began the "arduous task of taping the floors with rolls of brown paper and

setting out each box in a grid-like pattern of eight rows lengthwise." In fact, the Factory was being decorated in a way that made it as unlike a manufactory as can be imagined. Walls and ceilings were being covered with silver foil or silver paint by Billy Linich, a downtown bohemian who was to play a decisive role in determining the demographics in what came to be referred to as the Silver Factory, with Linich as a kind of factotum and supervisor. Meanwhile, he was pressed into service, along with Malanga, in painting the boxes in white or brown Liquitex, to match the colors of the original cardboard cartons. Malanga, a poet, had been hired early to help Andy make silk-screened paintings at the abandoned Hook and Ladder that had served as a temporary studio.

Meanwhile, the original cartons were flattened out, and silk-screen stencils were made of them by an expert. Once the underpaint had dried, Warhol and Malanga began silk-screening the painted boxes, ultimately producing replicas of what the eye would see as containers for juice or canned food or, in the most memorable of the boxes, Brillo pads. The "Factory workers" would move from box to box, completing perhaps two sides of a given sort of box in a day. The bottom was left blank, and unsigned. Malanga says that the grocery boxes were "literally three-dimensional photographs of the original products," which explains why they so looked like the originals. Of course, screens get clogged, and the paint gets splashed or dripped. But Andy never discarded anything. For Warhol, these "blemishes" were

part of the process. So the Factory's boxes would not have been tolerated in a genuine factory, which would exercise quality control. They look mechanical—in a way, and from a certain distance. For Warhol, the accidents were part of the process. So he never edited anything out. And these two qualities—unedited but mechanically reproduced—became part of the Warhol aesthetic, whatever medium he might work in.

Readers of Wittgenstein may be struck, as I was, by this picture of how the grocery boxes were created in the Silver Factory, and Wittgenstein's picture of a "language game" in *Philosophical Investigations*. A "language game" is a highly simplified situation in which a small numbers of objects are associated by a small number of words.

Here is the language game as Wittgenstein describes it: "The language is meant to serve for communication between a builder A and his assistant B. A is building with building stones: there are blocks, pillars, slabs, and beams. B has to pass the stones, and that in the order in which A needs them. For this purpose they use a language consisting of the words 'block,' 'pillar,' 'slab,' 'beam.' A calls them out;—B brings the stone which he has learnt to bring at such and such a call.—Conceive this as a complete primitive language" (Ludwig Wittgenstein, *Philosophical Investigations*, Oxford: Blackwell, 1958, I, 2).

The assembly line in the Silver Factory has one artist—Warhol—and two assistants, Malanga and Linich. Warhol calls out "box," and one or the other assistant brings a box. Warhol then

calls out "stencil," and the stencil is brought and positioned. Then Warhol calls out "squeegee," etc. Repeated orders and compliances soon enough create enough grocery boxes for a show. Whether this throws any light on the somewhat puzzling notion of "language game" I cannot say for certain, but the resonance between the two came to me in a dream while writing this book, and for better or worse I could not resist including the comparison here.

This brings us to the great philosophical question the grocery boxes raise. Whatever the accidentalities, the Factory *Brillo Boxes* look exactly like the real cartons one could see in the stockroom of any supermarket in the land. There is a photograph taken by Fred MacDarrah of Andy standing between some stacks of his *Brillo Boxes*, but anyone unfamiliar with cutting edge art in 1964 would have seen it as a photograph of a pasty-faced stock boy standing amid the boxes it was his job to open and unpack. In truth, it would have been impossible for anyone unfamiliar with avant-garde art in 1964 to have seen the boxes as art at all. One can put it even more strongly. It would have been impossible for Andy's boxes to have *been* art before 1964. The great art historian Heinrich Wolfflin said that not everything is possible at all times. The history of art opens up new possibilities all the time. But it would not have opened up the possibility of something like a Brillo box being art in, say, 1874, when the avant-garde art was Impressionist. Had such an object existed at that time, it was just possible that an Impressionist might have painted it—

but he or she would not have been painting a work of art. They would have been painting an object that had whatever function it might have had, but it would not have been art. The Impressionists had a hard enough time getting their paintings accepted as art in 1874. Many people saw their canvases as little more than paint rags. To see the Factory's *Brillo Boxes* as art, one would have had to know something about the recent history of art — know something about Marcel Duchamp, for example — and have some understanding of why someone would have made hundreds of objects that looked exactly like what could have been seen in any stockroom in America. What made Andy's boxes art, while their real-life counterparts were simply utilitarian containers, with no claim to the status of art at all? The question What is art? had been part of philosophy since the time of Plato. But Andy forced us to rethink the question in an entirely new way. The new form of the ancient question was this: given two objects that look exactly alike, how is it possible for one of them to be a work of art and the other just an ordinary object? One could say something like this: Andy's boxes were made of wood and the ordinary Brillo cartons were made of corrugated cardboard. But surely the difference between art and reality cannot consist in the difference between wood and cardboard! After all, there are plenty of boxes that are made of wood, in which, for example, wine is shipped. Or someone could say, Andy's boxes are full of accidentalities, while the commercial Brillo cartons are impeccable as far as printing is

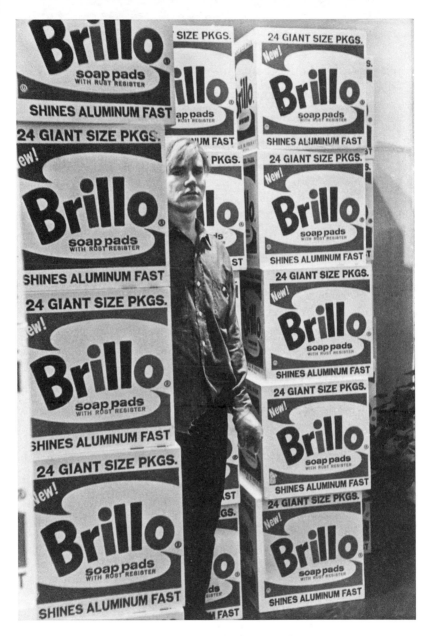

Major American artist/stock boy, or artworks/mere real objects? Noted *Village Voice* photographer Fred McDarrah recorded Andy and the *Brillo Boxes* at the Stable Gallery. Fred W. McDarrah/Getty Images

concerned. But Andy's could have been impeccable as well. The difference between art and reality would stand.

As it happens, the designer of the Brillo box was himself an artist—James Harvey, an Abstract Expressionist painter who was a part-time package designer. Harvey was stunned when he visited the opening of Andy's show of grocery boxes, realizing that he had designed the very boxes that the Stable Gallery was selling for several hundred dollars, while his boxes were worth nothing. But Harvey certainly did not consider his boxes art. They were, one might admit, commercial art. And as commercial art they were brilliant. There has to be an explanation of why everyone remembers the Brillo box, but not, say, the Mott's apple juice box. Andy gets no credit for the brilliance of *Brillo Box*'s design. The credit is entirely Harvey's. What Andy gets credit for is making art out of what was an entirely vernacular object of everyday life. He turned what no one would have considered art into a piece of sculpture. He did the same with boxes far more nondescript in design than the Brillo box—the Kellogg's Corn Flakes box, for example. Each of the eight varieties of grocery boxes was sculpture, not just the *Brillo Box*.

The writer Edmund White wrote that

Andy took every conceivable definition of the word *art* and challenged it. . . . Art reveals the trace of the artist's hand: Andy resorted to silk-screening. A work of art is a unique object: Andy came up with multiples. A painter paints: Andy

made movies. Art is divorced from the commercial and the utilitarian: Andy specialized in Campbell's soup cans and dollar bills. Painting can be defined in contrast to photography: Andy recycled snapshots. A work of art is what an artist signs, proof of his creative choice, his intentions: Andy signed any object whatever. Art is an expression of the artist's personality, congruent to his discourse: Andy sent in his stead a look alike on the lecture tour. [*Andy Warhol: A Retrospective*, 441]

We might qualify this by observing that Andy did *not* sign the grocery boxes. But White has it right: Andy negated pretty much anything philosophers have said about art. And it is fairly easy to understand how: nothing that the Brillo box and Andy's *Brillo Boxes* have in common can be part of the definition of art, since they look—or could look—absolutely alike. What makes something art must accordingly be invisible to the eye.

I shall not go further into what philosophers call the ontology of the artwork—what it is to *be* a work of art—what are the necessary conditions to be a work of art. For that I must direct the reader to my collected writings on the philosophy of art. Negatively, however, Andy's various challenges to what philosophers and others have said that art is *pale* in comparison with the grocery boxes. Since he has found an example of a real object and a work of art, why can't anything have a counterpart that is a work of art, so that ultimately anything can be a work of art? That

means at the very least a new era of art in which artworks cannot be discerned from real things, at least in principle—what I have called The End of Art. Critics have asked why I think Warhol ended the history of art as art had been understood before—why not Duchamp with his readymades? Well, Andy actually made his grocery boxes, whereas Duchamp could not, in principle, have made his readymades. But then not every object can be a ready-made, since Duchamp restricted readymades to aesthetically undistinguished objects. But why do that unless one has some animus against retinal art? One thing that has to be said about the *Brillo Boxes* is that they are beautiful. My wife and I have lived with one for years, and I still marvel at its beauty. Why live with dull anesthetic objects? Why not objects as beautiful as *Brillo Boxes?*

Andy's second—and last—exhibition at the Stable Gallery opened on April 21, 1964. The space was filled, floor to ceiling, with grocery boxes. The front room, on Seventy-fourth Street, was given over to the now familiar *Brillo Box* sculptures, red and blue on white, and there were about a hundred of them. The Kellogg's Corn Flakes boxes were in the rear gallery. The gallery was on the ground floor of an elegant upscale white-stone town house that has since been incorporated into the Whitney Museum as its business entrance. The entrance area has a black-and-white marble tile floor, with a delicate staircase to the right, and a polished brass balustrade. One entered the gallery itself through a large mahogany door, which, during the few weeks that

the show was up, had the utilitarian look of a stockroom. The contrast between the delicate entrance of the building and the space of the Stable gallery was like the contrast between waking life and dream—it was as if one were suddenly transported to a crass utilitarian space, radically discontinuous with the upper-class atmosphere of Madison Avenue and the Upper East Side of Manhattan. Entering the show was like living a surrealistic experience. The installation was by Billy Linich, and by my recollection it felt like a jumble, not quite the geometrically ordered edifice that corresponded to Warhol's vision. One had to follow a path through the piles, so the gallery was not crowded, although it was a show that everyone interested in art at the time had to see, and on opening night the lines stretched out the doors of the building and down the street. But that had more to do with the fact that there was room inside for only a handful of people at a time. Most of the literature on the *Brillo Box*, critical and philosophical, tends to talk about the individual boxes, since the art-reality contrast lies there. The term *installation* as a designation of a distinct genre of art first appears in the *OED* in 1969, but doubtless was in use before then. It is incontestable that Warhol's decision that the boxes had to be made of wood implies the effect he wanted to achieve when they are neatly and carefully piled next to one another, but it would be difficult to claim that his second Stable exhibition consisted of one single work. Most of the critical and philosophical literature on the *Brillo Box* treats the boxes as individual works because of the relationship between

them and the individual cartons of the supermarket. At the same time, it is possible to imagine Andy showing individual boxes on top of pedestals, as if they were portraits of Brillo cartons, or even fastened to the wall in one way or another, or aligned along shelves. He did not want to do that—though one saw them exhibited that way in museums and art galleries. It is really undeniable that he wanted them piled on the floor, and to have a massive presence—maybe like the piles of old automobile tires that Allen Kaprow installed in the courtyard of the Martha Jackson Gallery, just down from the Stable Gallery. Kaprow used the word "environment," in contrast with the word "ensemble" used by Louise Nevelson to identify her great 1958 exhibition at the Nierendorf Gallery. She envisioned the gallery as one gigantic sculpture or "ensemble." "Everything has to fit together, to flow without effort, and I too must fit," as she explained to a *New York Times* reporter. Nothing could be further from the concept of ensemble than the gallery full of grocery boxes!

The show was a critical success, but not a commercial one at all. There were a lot of leftover grocery boxes. In early 1965, a Toronto art dealer attempted to import eighty of the boxes into Canada, but ran into difficulty with Canadian customs. As sculpture, they would have entered duty-free, but customs considered them merchandise and demanded an import tax of $4,000. It was like the celebrated case of Brancusi's *Bird in Flight*, which actually went to trial when U.S. customs refused to admit it as art and classed it with kitchen utensils and hospital supplies, and

demanded a tariff be paid. (Incidentally, Brancusi's sculpture carried a price tag of $240 in 1927, while Warhol's boxes were valued at $250.) The matter was referred to Charles Comfort, director of the National Gallery of Canada, who agreed with customs after being shown some photographs of the grocery boxes. "I could see," he said, "that they were not sculpture."

This fiasco has a philosophical aspect as well as a comical one. In the 1960s, and much as a result of the appearance of such works as *Brillo Box*, philosophers became interested in the question sketched above—what constitutes an artwork, especially one like *Brillo Box*, which looks for all practical purposes like an ordinary grocery. One position, still widely canvased, was advanced by the American philosopher George Dickie in a definition known as The Institutional Theory of Art. For Dickie, something is a work of art when it is (1) an artifact, and (2) considered by the art world as a "candidate for appreciation." The case of Charles Comfort shows that the art world is not a single body. One would certainly regard museum directors as part of the art world. Perhaps the art world could be thought of as an electorate, and something art if the majority of art-worlders vote it in as art. Unquestionably there is more to the matter of what is art than consensus. Ultimately there have to be reasons for something to be art. In the great dialogue *Euthyphro*, Socrates examines the argument that something is holy if the gods love it. Do they love it because it is holy, he asks, or is it holy because they love it? If they love it because it is holy, we can discover what their reasons are, and

hence be judges, as good as they, on what is holy and what is not. If, on the other hand, it is holy because they love it, there is the question of what that should matter to us. Art is like that. In some footage used by documentary filmmaker Ric Burns, a female reporter interrogates the artist. "Andy," she asks, "the Canadian government spokesman said that your art could not be described as original sculpture. Would you agree with that?" Warhol answers, "Yes." "Why do you agree?" "Well, because it's not original." "You have just then copied a common item?" "Yes." The interviewer gets exasperated. "Why have you bothered to do that? Why not create something new?" "Because it's easier to do." "Well, isn't this sort of a joke then that you're playing on the public?" "No. It gives me something to do." Andy is wearing sunglasses, and speaking in an entirely affected mode of speech, which goes perfectly with the air of stupidity he used as a kind of camouflage. Castelli's director, Ivan Karp, was standing next to him, smirking. Andy had left the Stable Gallery. Castelli's was exactly the right gallery for him. Leo Castelli was the great judge of what was new and important in the art of the 1960s. He represented Andy's heroes, Robert Rauschenberg and Jasper Johns. He justified his original decision not to take Andy on because he felt that his work was too close to Lichtenstein's, but now that he had moved into sculpture, there was a place for him. That was the gallery Andy had aimed for since he first decided to become an artist. Eleanor Ward had been humiliated by the grocery boxes, and there were tensions between her and Andy over money. And

in addition to being dubious about the grocery boxes, she saw no market in America for the Death and Disaster works. Andy's first show at Castelli's consisted of *Flower* paintings, which sold very well. The idea once more came from Henry Geldzahler, who said that Andy had done enough with the subject of death — it was time for some life. The *Flower* paintings were also shown in Paris, at Ileana Sonnabend's gallery, where Peter Schjeldahl, the American critic, at the time a poet, saw them. He had gone to France to write, as so many young Americans had done, turning their backs on American culture. When he saw the flowers, he realized, as he likes to say, that he was in the wrong country, and immediately made plans to return to America, where art was real.

Moving Images

One of the few works of fiction I am aware of based on Andy and his Factory— *Who Killed Andrei Warhol?* —has the form of a diary kept by a Soviet journalist who arrives in America in early 1968 to cover what he is certain will be the inevitable revolution. By that time, the Factory had been moved from Forty-seventh Street to a building on Union Square, which also housed the headquarters of the American Communist Party. The comically muddled diarist is convinced that "Andrei" is a proletarian artist, whose art is the real Socialist Realism. "He is a socialist realist through and through," the journalist writes in his diary, "but one who has succeeded in transposing this art form to capitalist conditions. And in the process he has subverted capitalism" (Motyl, 49). This marvelous misreading is not that different from what European Marxist critics wrote tirelessly about Warhol in left-wing

journals. At their mildest, they argued that Warhol was satirizing capitalist culture. In fact, Pop art was seen by artists in the Soviet bloc as out and out liberating: Zotz Art, as the dissident Soviet painters Komar and Melamid called their work, were ways of mocking the high-minded official Soviet paintings that showed heroic workers, in factories and farms, exceeding their quotas. But, as we have seen, Andy's art was celebratory and patriotic. He was a liberal, and a Democrat, who wished, he once told one of his associates, that he was able to be a Republican, but he could not make the switch. He once did a poster which shows President Richard Nixon with a frightening green face. Beneath it he printed: "Vote for McGovern"—Nixon's Democratic opponent in 1972. He donated the proceeds to the Democratic Party, and it sold so well that he turned out to be the party's largest contributor. In consequence he was repeatedly subjected to punitive audits by the Internal Revenue Service. That is why, in his so-called *Diaries*, which consisted of his daily phone conversations with Pat Hackett, his girl Friday, he is constantly reminding her to get receipts.

Had the Soviet journalist visited the Silver Factory in early 1964, he would have seen Andy and his helpers seemingly pretending to be proletarian industrial workers, mass-producing grocery boxes, the way, if he were aware of the comparison, Marie Antoinette and her handmaids played at being milkmaids in the elegant little *Laiterie de la Reine*—"The Queen's Dairy"—in Rambouillet. Warhol never, to my knowledge, did sculpture

at the Silver Factory after the second Stable Gallery show—the 1970 edition of *Brillo Boxes* was actually fabricated, as were the inflated *Silver Clouds*, which, together with the cow wallpaper, constituted the first of his shows at Castelli's. And Warhol "retired" from painting in 1965. His main creative impulses by that time were in movies and in television. The Silver Factory had been transformed into a film studio.

In the early 1960s Warhol became fascinated with the thriving if somewhat primitive "underground film" movement in New York. His own early films photographed ordinary people engaged in the basic activities of life—eating, sleeping, having haircuts, smoking, drinking, and engaged in sexual acts. Someone might see this as continuous with what he had been painting—cans of soup, storm doors, refrigerators, grocery cartons—the commonplace and everyday—what everyone does everywhere most of the time. Everything was interesting, nothing was more interesting than anything else. The sheer fascination with what everybody knows was enough to justify films of whatever length, in which nothing more interesting happens than just leaving the trace of itself on strips of film. Moreover, almost from the beginning, the Silver Factory became a "scene"—a place where people dropped in and became part of what was happening. It was certainly unlike any art studio of the time in its openness. Work went on, but a lot more than that went on. Andy's film activity was well under way by the time that the grocery box project had begun, and beyond question the glamour of film was certainly a drawing

card for numbers of attractive if not particularly talented persons. Andy's first film, *Sleep*, was a gift of sorts to his boyfriend of the time, John Giorno, a poet. The thought was that it would make Giorno a star. So from the outset, making films was an act of love for Warhol.

The art historian Leo Steinberg wrote an intriguing essay on a particular genre of Picasso's work, consisting of a figure, usually male, watching a woman sleep. Steinberg speaks of these figures as *sleepwatchers*, hence a certain kind of voyeur. "The artist must have known from the beginning that the subject was old," Steinberg writes. "Scenes of sleeping nymphs observed by alerted males—scenes concerned with longing and looking—are part of the grand tradition of art, in antiquity and again since the Renaissance" (Steinberg, 95). I do not know whether there were underground engravings of one gay lover watched by another as he sleeps. Giorno made a point of sleeping when most people, especially those who used amphetamines, tried to make do with as little sleep as possible. But the existence of the tradition to which Steinberg drew our attention suggests that sleepwatching is connected, if not with love, then certainly with sex. Giorno published a pretty explicit memoir of the making of the film. He and Andy were lovers, he goes to some pains to explain, in the sense that they loved one another—Andy even introduced Giorno to his mother! But sex between them was complicated by the fact that Giorno found Andy physically unattractive. "He happened to be ugly, he understood that, and nobody wants to be compro-

mised" (Giorno, 132). Women are less fussy than gay males about such matters, but Giorno was compassionate, and they obviously found ways around the aesthetic obstacles. "I did it because he wanted it so much. He was pathetic and I loved him." In any case, Andy was a sleepwatcher. Giorno describes waking up out of a drunken sleep to find Andy looking at him. When Giorno asked him what he was doing he said: *"Watching you sleep!"*

Andy started shooting *Sleep* in August 1963. It took a month, largely because he did not really know how to use the somewhat primitive Bolex camera he had acquired. He took hundreds of four-minute rolls of film but knew little about how to edit them. Finally he decided, characteristically, to "just use everything." He had done that with photo booth shots too, as if, by showing the same face in many expressions, he was spared the need to select, and somehow had the whole person down. Giorno describes how *Sleep* was screened for Jonas Mekas, the dean of Sixties underground films in New York. Mekas put a still from the movie on the cover of *Film Culture* and arranged a world premiere "in an old run-down movie theater near City Hall" (Giorno, 142). Projected at the slow-motion speed of sixteen frames per minute, *Sleep* lasts for five hours and twenty-six minutes, so most people who have seen it will at most have seen clips of varying lengths, consisting of shots of the sleeper's sleeping body.

In none of the silent, so-called minimalist films is there anything much to see, not even in the 1964 *Blow Job*, which shows the face of an attractive if anonymous young man who is being

fellated off-screen. So the title seems like false or at least misleading advertising. It was too long, however short a time it lasted, and nearly caused a riot when shown at Columbia University, together with a concert by Warhol's rock group, The Velvet Underground, in 1966. The students were impatient and filled the air with boos, hisses, and jokey singing of "He shall never come." "We thought the students would be our allies," Gerard Malanga told me. Andy was in the audience, planning to say a few words after the screening, but he left quietly when the furor started.

The masterpiece in this genre is beyond question the film *Empire* (1964), which runs for just over eight hours, with a minimum of incident and one actor, namely the Empire State Building itself, filmed from a window in Rockefeller Center with an uninterrupted view of the building, using an Auricon movie camera, roll after roll, spliced together in the order of exposure. In my view, it is a philosophical masterpiece, nearly as profound as *Brillo Box*. Let me explain why. Philosophers since antiquity have been concerned with the analysis of concepts, which in effect means that they have been engaged in seeking definitions of a certain sort. The great dialogues written by Plato that feature his hero, Socrates, trying to clarify the meaning of some contested term, are examples of seeking definitions that would hold water of such terms as justice, truth, knowledge, beauty, friendship, and courage. It was never done in the spirit of lexicography, but rather of better understanding the language we use in making the

distinctions we do. Socrates' partners in dialogue typically offer definitions that reflect their position in life. In *The Republic*, an older gentleman, Cephalus, defines justice as "telling the truth and keeping your promises"—just what a businessman might think suffices to be considered a just man. His son, Polymarchus, a soldier, thinks justice is "helping your friends and harming your enemies." Definitions are proposed, exceptions are sought, and then one seeks ways of plugging the holes in the definition that the exceptions opened up. My own interest has been in the definition of art, which made *Brillo Box* so important to me. The test was to see what made it art, which nothing it had in common with the commercial object, the workaday Brillo cartons, could explain, much alike as they looked. One could ask, in other terms, what the essence of art consisted in, but the challenge was to explain why Warhol's box was art while its look-alike in common life was not.

Suppose someone asked of what the essence of moving pictures consists. It cannot be that they contain images, since so do still pictures, such as Cindy Sherman's brilliant untitled Film Stills. So someone might say: the images move. But in fact the image in *Empire* does not move at all! Two screens, one showing *Empire*, the other a still of *Empire*, look as much alike as *Brillo Box* looks like a box of Brillo! Once, sitting at a showing of *Empire* at the Whitney Museum, I heard a man ask when the film started. It had been running for fifteen minutes! If one looked carefully, one could see bubbles and scratches move by. So perhaps one might

say—a moving picture is not a picture that moves, but rather a strip of film that moves. Warhol intuitively thought like Socrates or one of his partners, offering and testing definitions. He was after the essences of things. He showed, here, that in a moving picture, nothing in the picture has to move. Actually, it would only be in a moving picture that something would actually stand still. No one looking at a snapshot of the Empire State Building would ask: Why is it not moving?

For all its epic length, very few of the Factory figures were involved in shooting *Empire:* Andy himself, Gerard Malanga, John Palmer (who gave Andy the idea of doing a portrait of the Empire State Building), Jonas Mekas, and one or two others. Andy had rented the Auricon camera, a much more evolved instrument than the Bolex, using packs of film that ran for thirty-five rather than four minutes. Palmer's "script" evidently called for panning shots, but once the building was framed Andy insisted that nothing be done beyond changing the film. The building, not the camera, was the hero. Nothing was to happen in the film other than what happened to it. "After the dramatic first reel, in which the sun sets and the exterior floodlights on the building are suddenly turned on the only action in the film is the occasional blinking of lights until . . . in the next to last reel, the floodlights are turned off again." So writes Callie Angell, the leading expert on Warhol's filmic undertaking (Angell, 1994, 126).

Among the films Warhol made are about three hundred so-

called Screen Tests, which he began to film in 1964, and it was these that, bit by bit, began to change the demographics of the Factory. Andy invited people to stop by for a screen test if he found them interesting or attractive enough. Many of these found the Factory atmosphere congenial and became regulars, some of them helping out on film crews or even becoming actors, and some among them became "Superstars." But that does not mean that he could not tell a story, as some commentators have argued. When he used narrative content, as in his 1967 *Lonesome Cowboys*, for example, he begins with a situation—a bunch of cowboys on a ranch owned by a woman, played by Viva. The cowboys engage in a lot of horseplay, some of it sexually violent—they pinch one another's nipples, or threaten to brand one of the gang. At one point there is what looks convincingly like a gang rape of Viva. But then there is a kind of bonding that begins, between the men, and even a sort of love scene, between "Ramona," as the character played by Viva is called, and one of the cowboys, which is an effort at tenderness, even if futile. I find the scene where they strip themselves naked in a kind of green bower really beautiful, with Viva, despite her goofy diatribe against wearing pants, looking like a mannerist goddess by Correggio. Warhol said, when asked what he thought about the festival of his films that was to take place at the Whitney Museum in the 1980s, that they were always more talked about than seen. But the emotions displayed in *Lonesome Cowboys*, just for one, were far more human, far deeper, than the stereotyped displays of human feeling the typical Hollywood

cowboy film was able to get away with. The film is far more than
the gay spoof the secondary literature describes it as.

By 1965, Warhol had already made most of the works on which
his fame as an artist rests—the *Campbell's Soup Cans*, the *Brillo
Boxes*, the *Do It Yourself (Flowers)* paintings, the *Marilyns*, the
Jackies, the *Elvises*, the *Liz Taylors*, the *Mona Lisas*, the *S&H Green
Stamps*, the *Dollar Bills*, the Death and Disasters. That year, when
he exhibited his *Flower* paintings at the Sonnabend Gallery in
Paris, he announced his "retirement" from painting. "I knew that
I would have to move on from painting," he said in an interview.
"I knew I'd have to find new and different things." His plan was to
give himself over entirely to making films. Of course, paintings
and prints would continue to be produced, if only as means to
finance his cinematic enterprise, but film, and later video, made
these more traditional artistic outlets seem limited: "No one," he
declared, "can show anything in painting any more, at least not
like they can in movies." This claim must sound somewhat ironic
in view of Warhol's most legendary achievements as a cinema-
tographer: films of an inordinate length with a near zero degree
of incident—moving pictures in which nothing in the picture
moves.

These unprecedented films reinforced Warhol's impulses as
an avant-garde artist, but they did not entirely characterize his
ambitions as a filmmaker. He was not content to be on the cut-
ting edge of conceptual experiment in the foundations of art. He
aspired to the kind of glamour and commercial success connoted

by the Hollywood hit, and bit by bit the productive organization of the Factory had been reconfigured to reflect the differences between making images to be shown and sold in art galleries—for a while, he even considered selling the Screen Tests as "moving portraits"—and making films to be distributed in commercial movie houses. By 1966, when Warhol enjoyed considerable success with *Chelsea Girls*, the transformation of the Factory was more or less complete. Without losing its bohemian identity, the Factory had become a remarkably efficient engine for producing films that at least certain audiences were willing to pay to see.

It was doubtless because Warhol had begun to be perceived as a moviemaker—he was given the Independent Film Award by the magazine *Film Culture* in 1964—that he was lent a home video camera by a manufacturer, to see what he might come up with. What he initially came up with was not in any obvious way different from what the home video camera was to be used for by ordinary persons in ordinary life—to record friends and family members engaging in various activities. Warhol taped some of the personages for whom the Factory had become a kind of home—Edie Sedgwick, Ondine, Billy Name. It was consistent with the avant-garde spirit of his early films that these first videos should have had the format of home movies, since it belonged to that spirit to remove from art any trace of the artist's eye or hand. The avant-garde artists of the mid-1960s were very much the children of Marcel Duchamp, who sought an art which "consisted above all in forgetting the hand." The image we have of

Warhol simply aiming a camera, fixed to a tripod, and letting it run without interruption, is a vivid emblem of this austere aesthetic. He would even, as we saw with the Screen Tests, walk away from the camera, leaving his subjects to sink or swim. Vincent Fremont, Warhol's closest associate in developing himself as a TV artist, is cited as saying that Warhol would have liked the camera to run constantly. It was as if his ideal video would be the kind of tape produced by a surveillance camera, indiscriminately registering whatever passed before the lens. Warhol, who famously claimed to like boring things, appeared at times to seek an entirely mechanical art, from which the artist had disappeared in favor of a running record of whatever took place in the outside world. This way of making art served fairly well for someone who, like Warhol, found the ordinary world fascinating just as it was. His one effort at "writing" a novel—*A: A Novel*—was a transcript of audiotapes of twenty-four not necessarily continuous hours in the life of Ondine, whose sarcasm and wit were deemed so outstanding that they seemed to merit preservation. It might strike the reader like a page from James Joyce's *Finnegan's Wake*. But it was not invented. The incidents were not contrived. The prose is charmless. It is like an interview in which all the "yeahs" and "uh-huhs" are preserved. Any effort at editing would be a violation of the "author's" intent. It would hardly serve the purposes of making commercially ambitious television programs, as he hoped to do. I'll discuss Ondine in the next chapter.

In 1971, Warhol acquired a more advanced video system—a

Sony Portapack—and announced, according to Bob Colacello, the editor of *Interview* magazine, that he was "going into the TV business" (Colacello, 61). This was interpreted to mean that he intended to use it "as a way of trying out ideas for movies." Through the 1970s, however, Warhol continued to employ video in much the same way as he had—turning those who came within the Factory's orbit into subjects and, in a sense, "stars." From 1971 to 1978, he made a series of tapes designated *The Factory Diaries*—uninflected footage, still in the minimalist genre of home movies of individuals who sought new identities for themselves in the Factory—the transvestites Candy Darling and Jackie Curtis, Brigid Berlin, Lou Reed, Ultra Violet, Viva—as well as a number of personages who brought their own glamour into the Factory—Mick Jagger, David Bowie, Dennis Hopper, Yves Saint-Laurent, and others. Callie Angell describes this as "an extraordinary social scene" in which "increasing numbers of visitors from an expanding number of overlapping art worlds dropped by to see Warhol and, in many cases, appear in his films" (Angell, 1994, 128). The *Factory Diaries* have much the same unedited and nondirected quality as his early movies. Individuals of varying degrees of interest were filmed doing nothing special. "Nothing Special," in fact, was a title Warhol proposed for one of his early television shows.

Television increasingly defined Warhol's artistic ambitions. "My movies," he said, "have been working towards TV. It's the new everything. No more books or movies, just TV." The *Fac-*

tory Diaries scarcely seem that new, in the overall context of his oeuvre, but alongside the taping of Factory regulars and outside celebrities Warhol was seeking a more viable format for television than anything the surveillance camera could yield. It was only in the 1980s that his work began to approach the professional quality of commercial TV, something his films never really achieved. Warhol's films, even at their best, have the ineradicable improvisational scruffiness of the avant-garde of the 1960s. But that means that in some ways Warhol's television is much more like commercial television than it is like the rest of his more familiar work as an artist. Even so, Andy Warhol's TV is in important ways deeply continuous with that work.

Only the most dedicated of viewers would be prepared to sit through the monotonous entirety of his 1964 film *Empire*. Were *Empire* televised, the ordinary viewer would suppose that the channel was having transmission problems. It takes a certain physical effort to walk out on boring films, but channels are effortlessly changed when television bores. A television audience cannot be counted on to enjoy boredom. Commercially successful television has to hold the attention of viewers with fickle interests and zero tolerance for dullness. It has to attract audiences that know and care little about the preoccupations of the avant-garde.

Warhol grasped part of this truth in projecting his own image into public consciousness in the late 1960s. Even today he is probably the only American artist whose face is recognized by

everyone in the culture. His words are widely quoted, and persons who know little else of contemporary art instantly recognize his works. Everyone would have known "the famous artist Andy Warhol" when he was given a cameo role in the television show *The Love Boat* in 1985. The mere fact that it was *Andy Warhol* on the screen would give anyone a reason to keep tuned in long enough to see what he said or did. People would almost certainly have been bored by films like *Empire*. But the fact that someone actually made such a film was not boring at all. Few people would have been interested in contemplating a soup can. But everyone was fascinated by an artist who actually painted so aesthetically unpromising an object. Warhol knew that he was an object of fascination. But there must have been a moment of insight when he decided to build television shows around himself. In his earlier video efforts, he was external to the action, as director. His television became interesting when he was also internal to the action, as a star in his own right. The remaining problem was what else there had to be in the action to give the shows an interest as entertainment, and the obvious answer was: personalities as fascinating as himself. All he needed to do was surround himself with personalities he would be interested in watching when he was not interested in cultivating boredom.

One learns from Vincent Fremont how seriously Warhol took this project. At one point they produced *Fight*—a video in which Brigid Berlin and Charles Rydell argued with one another. Fights between couples are standard occurrences in a certain genre of

sitcom, and it was evidently Warhol's idea to reduce a sitcom to this one incident. Later, he attempted to combine the fight with a dinner party, with interesting guests—fusing, so to speak, the sitcom and the talk show. The result, according to Bob Colacello, "was just too amorphous and amateurish to make it into anything viable" (Colacello, 145). Warhol realized that he and his associates had to go back to the beginning, and really learn how to produce television of professional caliber. He even invested in a very expensive broadcast camera. By 1979 he found the format that, with minor differences, was to characterize his television efforts through the 1980s, culminating in *Andy Warhol's Fifteen Minutes* of 1985-87. It was a format in which he was host to celebrities who enacted for the viewing audience the kinds of things that gave them celebrity. He gave embodiment to his own fantasy of being a celebrity in a world of celebrities—a world of fashion, of art stars and music stars and stars of beauty, and of the places in which they glittered—the discos and hot scenes everyone wanted to know about: the Mudd Club, the Tunnel, Studio 54. Warhol produced shows which have something of the excitement of glossy magazines, filled with images of the fair and famous, which keep us turning the pages to see what's on the next page (and looking at the ads as we do so). This world is, in Shakespeare's words, "an insubstantial pageant," and though an anthology of memorable moments in the various programs could be compiled, it is part of belonging to that pageant that fame is ephemeral (lasts for "fifteen minutes"), brightness yielding to

the next bright thing. Stars dazzle and fade, so there can be end-less shows, fascinating to watch and difficult to remember. But Warhol, always present, gave his television its continuity.

Warhol died in 1987, leaving a question of how far Andy Warhol TV Productions might have gone had he lived. It is always difficult to predict the creative trajectory of an artist, let alone an artist of such tremendous originality as Warhol, but there is a certain consistency within his work, whatever medium he worked with. His subject was the common consciousness of his time—the ordinary life-world, as phenomenologists designate the world in which we are all at home. Warhol shows what everyone who shares this world already knows, without having to be told what they are looking at. The stars are an important component of our common consciousness, so he painted Marilyn and Liz and Jackie, and Elvis. He would have filmed them had they come to the Factory, just as he filmed the stars that did happen to come along. Everyone is interested in stars. So his television would be interesting if it did little more than show the stars, himself, of course, included. As a person, Warhol was obsessed with glam-our, beauty, parties, shopping, and sex. There is a memorable episode in which his head rolls off (one of the things painting cannot show). The disembodied head says, "Have a good time at all the parties!" which could have been his parting message to the world. Unquestionably, being a TV producer and the host of his own TV program gave him even greater access to these things.

Warhol seems to have known from within what everyone would like to see.

But to make the kinds of shows that common audiences would actually find entertaining, a lot of technology would have to be in place. And this implies a certain internal limit on how far his television could go. It is interesting to compare the credits for the earliest of Warhol's videos with those for *Andy Warhol's Fifteen Minutes*. At the beginning there was just Warhol and Fremont. Don Monroe was added as director in 1979, when the work began to take on a professional allure. *Andy Warhol's Fifteen Minutes* credits, in addition to Warhol, Fremont, and Monroe, a whole production team: a production manager, a production coordinator, a number of production assistants, editors, graphic artists, music researchers, composers, as well as the stars. Warhol had come a long way from what he was able to do single-handedly with a Norelco I camera in 1965. His TV attained a quality that justified its being shown in an MTV time slot. But the productive capabilities of the Factory were probably too limited to go much further, or even to sustain a season of shows. For this, more money and perhaps a lot more money would be required. But this exposed Warhol to something he had not reckoned with when he struck a Faustian bargain to make commercial TV: the intervention into his artistic decisions by others over whom he had no control.

There is an instructive passage in Colacello's book *Holy Terror*—a memoir of his life as part of the Factory. A meeting had

been arranged between Warhol and Lorne Michaels, the creator of *Saturday Night Live*. Michaels was very excited by the prospect of Warhol TV. He offered development money and a prime-time Saturday night slot. "They could do whatever they wanted: He would protect them from the network bosses who might question some of their more experimental ideas." Through all of this, Warhol said not a word, and Vincent Fremont saw immediately that nothing could come of this offer. "Andy could not stand paternalism in any form. Behind his passive façade, he had to be in control." His "passive façade" was a way of exercising control. In this respect, Andy Warhol TV Productions had to be essentially a Factory operation. There could be TV only so long as Warhol need involve no one else in the integrity of his art. In that sense the Factory as TV studio was little different from the Factory as art studio or movie studio. And that is what makes Andy Warhol TV so uniquely his and so completely him. He went as far as he could in commercial television without surrendering his autonomy. His television is the unlikely product of two different imperatives—the imperatives of commercial entertainment, and the imperatives of a fiercely independent artist, responsible to no one but himself.

The First Death

The story of life in New York City is the story of real estate, and real estate, accordingly, is as absorbing a narrative topic as love: the story of where one lives or might have lived is as compelling as the story of how you met the person you live with—or, alas, no longer live with. That is the premise of Tama Janowitz's comic masterpiece, *Slaves of New York,* wryly recounted in the first person by a downtown woman somewhat older than a sullen painter whose fictional name is "Stash"—and whose name in real life is Ronnie Cutrone, who was Andy Warhol's studio assistant from 1972 to 1982, though he was a hanger-on at the Silver Factory beginning around 1965. In view of the way that Warhol was often dependent on those around him for his ideas, Cutrone played an important role in the later phase of Andy's artistic career. If Stash is a fair portrait of Cutrone, Eleanor, the "slave of New York," had

her work cut out for her, since not only does he hold the lease on the space they cohabit, but he has a roving eye for sexually attractive chicks. Eleanor is largely penniless—her "creativity" consists of designing original hats for East Village women—so she lives on the brink of homelessness unless she continues to find favor in Stash's faithless eyes. Whether the stories were a true mirror of New York life in the 1970s, they constituted a metaphor that every New Yorker understood. Unless they held the lease themselves, every New Yorker, man or woman, married or unmarried, was in bondage to the leaseholder they lived with.

Office space, obviously, is a different, less heartbreaking kind of story. But the "culture" of a commercial space is more dependent on what makes real estate real than mere architectural truth. Silvering the Silver Factory eloquently expresses the spirit of New York artistic life of the mid-1960s, and it did not survive the next move that Andy Warhol Enterprises was to make at the end of 1967, when, as leaseholder, he was told that he was going to have to vacate, since the building the Silver Factory was in was scheduled to be demolished and replaced by a contemporary apartment building. The silvering went with the youth culture of its occupants, the music they danced to, the kind of drugs they got high on or addicted to, and with their sexual looseness or uptightness, even their language, if one follows Wittgenstein's dictum that to imagine a language is to imagine a form of life. The space "made a statement," and the statement was internally related to the art produced and responded to there, mainly underground movies.

Painting the Factory silver was the idea of Billy Linich—or "Billy Name," as he came to be called—who first silvered his apartment when someone administered amphetamines to release him from a sort of lingering torpor that had robbed him of energy. It was Andy who subsequently proposed that Billy silver his new studio, and Andy that gave an interpretation of the statement he felt that silvering it made: "It was the perfect time for silver. Silver was the future . . . the astronauts wore silver suits. And silver was also the past—the silver screen—Hollywood actresses photographed in silver sets." Silver was the color of the "Silver Surfer" and of the platinum blondes of Art Deco times.

Linich was the only one who actually lived there—he took possession of one of the bathrooms, which he also used as a darkroom for developing the photographs he took, chronicling life in the Silver Factory as it evolved. It says a great deal that of Warhol's two lieutenants, Billy Linich and Gerard Malanga, Malanga received a salary, however minimal, while Billy Name was merely given spending money. Malanga was a grown-up, a jobholder, identified with the photographic silk-screening process and the mass production of the grocery boxes; Billy Name had the ambition of a perpetual adolescent, living at home, helping with household chores, and making do with an allowance for his personal needs.

Most of those who used the Silver Factory as their "club" would not have lived there. Either they lived at home and hung out in the Silver Factory, or they had money and lived indepen-

dent, urbane lives. But they believed in the life that the Silver Factory emblematized, of freedom spiced by the license that bohemia claimed for itself. They were often celebrities. A friend of Andy's hosted a Beautiful People Party in the spring of 1965, where Judy Garland, Rudolph Nureyev, Tennessee Williams, and Montgomery Clift came as invited guests. Andy by that time was himself a Beautiful Person—a star and indeed an icon. But none of the Silver Factory regulars had quite the necessary glitter for that. They were young, good-looking people with whatever allotment of talent may have given them hope for stardom, and who had been brought to the Silver Factory by Malanga or by Linich, who had access to different pools of recruits, or by Andy himself, who spotted what he thought might be talent at the nightly parties he attended.

Billy Name makes an appearance on Ric Burns's four-hour television special on Warhol, aired in 2006, in which he declares, with a kind of gleeful cackle, that he was the one responsible for the downtown presence in the Silver Factory. He had come to New York in the late 1950s—an attractive young man, lean and dark, drawn to bookstores and a certain kind of gay bohemia, where he made friends and looked for protectors. He became part of a group that came to be called—that called themselves—the Mole People—people of a certain talent, early users of speed, with a taste for grand opera and a marked anarchistic lifestyle, and gifted with a rude and cutting wit, a free and open sex life, and a dedication to mischief. The "Pope" of the Mole People

was Bob Olivo, whose Factory Name was Ondine—an inspired monologist and lip-syncher, a compellingly original and bizarre personality.

Here is a picture of Ondine and of the Mole People from Mary Woronov's memoir, *Swimming Underground: My Years in the Warhol Factory*:

Ondine was like the Cyclone—he thrilled and terrified me though I knew I was in an amusement park. Rooms grew old when he left, and after talking to him I couldn't bear normal conversation. I started going places to be around him, the gayest bars, the most bizarre parties. I was fearless and it was only a matter of time before I was introduced into an extremely narrow circle that surrounded Warhol during the days of the Silver Factory on 47th Street: the Mole People. Mole because they were only seen at night wearing sunglasses and a skin pallor that had to be the result of years of underground existence; Mole because they were known to be tunneling toward some greater insanity that no one but this inner circle was aware of. Some of the Great White Moles were Ondine, the Pope; Rotten Rita, the dealer; Orion, the witch; and of course Billy Name, the protector of the Factory. . . . Drella warned me to steer clear of the Mole People, so I kept my distance until one night Ronnie invited me to get high with them. Ronnie was a rather handsome straight looking but totally speed crazed homosexual whose last name

was Vile in case anyone was fooled by his pleasant manner.
He said that for the last five days the Moles had been cooped
up in an uptown apartment making necklaces, and all I could
think of was that they must have some powerful dope to keep
that bunch stringing beads for a week. But the real reason I
got in the cab with Ronnie was because he said Ondine would
be there. [Woronov, 62–63]

In the course of that evening, Woronov, an actress and writer,
with a certain touch of sadism and an unmistakable courage, was
finally captured by the perpetual Walpurgisnacht that was Mole
reality. She ultimately left the party and went home. "But I didn't
belong. I had changed. There were no outward signs, but I knew
it. It was no longer them, it was us. Their rules were mine, their
insanity my reality, and as for the rest of the world, it just didn't
matter. I was a Mole" (72).

Andy was so captivated by Ondine's style of wit that he pursued
him with a tape recorder for twenty-four hours in an attempt to
preserve everything that Ondine said in that interval. At least that
is what he assumes. One might be able through textual detective
work to identify the actual date—the way one can find out that
June 16, 1904, is Bloomsday: the actual twenty-four hours lived
through by Joyce's hero, Leopold Bloom. But of course Joyce
did not write the book in that twenty-four-hour interval. War-
hol wanted it to be a "bad book"—the way, I suppose, his movies
were bad movies and his paintings bad paintings, according to

initial criticism. When the transcription of his tapes was given to him, it was full of errors and inconsistencies, but, true to character, he decided to publish it just as it was, saying, "This is fantastic. This is great!" And in a way it is fantastic and great: it really refuses to distinguish what people say from the circumambient noises that the tape recorder picked up, and which somehow got transcribed. Like "Rattle, gurgle, clink, tinkle. / Click, pause, click, ring. / Dial, dial"—with which the book begins. But these are names of noises, not noises themselves, which we would hear if we listened to the tapes. The book can certainly be considered avant-garde literature (the huge "A" at the beginning of the book is obviously meant to remind the reader of a typographical peculiarity of *Ulysses*). But it does not do what Warhol meant for it to do, namely, give us a sense of Ondine's wit! Compare *A* with the voice of "lui" in Diderot's masterpiece, *Rameau's Nephew*, who knows that he is gifted but not a genius like his uncle, though no one—and certainly not his uncle—could duplicate the nephew's wild way with language and sound, which Hegel transcribes in a passage in the *Phenomenology of Mind:*

> This style of speech is the madness of the musician, "who
> piled and mixed up together some thirty airs, Italian, French,
> tragic, comic, of all sorts and kinds; now, with a deep bass,
> he descends to the depths of hell, then, contracting his throat
> to a high piping falsetto, he rent the vault of the skies, raving
> and soothed, haughtily imperious and mockingly jeering by

turns . . . a fantastic mixture of wisdom and folly, a melee of
as much skill as low cunningly composed of ideas as likely
to be right as wrong, with as complete a perversion of senti-
ment, with as much consummate shamefulness in it, as abso-
lute frankness, candor, and truth." [Hegel, 543–54]

A: A Novel was not published until 1968. But somehow one feels
as if the spirit of Warhol's failed experiment is what underlaid
Willem de Kooning's admittedly drunk diatribe at a party in
1969: "You're a killer of art, you're a killer of beauty, and you're
even a killer of laughter. I can't bear your work" (Bockris, 320).
Even if one takes *A: A Novel* to be a philosophical demonstra-
tion that avant-garde literature, as practiced by a tape recorder,
is impossible, he managed to kill laughter. Joyce, after all, said of
Finnegan's Wake that it was written for the laughter of mankind.
And one can get from Warhol's various biographers a pretty good
sense of Ondine's wit. On page 190 of *A: A Novel,* one can get a
sense of Ondine as a raconteur. But it is an agony to read that far.
One of the episodes in *Chelsea Girls* tracks Ondine through an
epic tantrum that made him a Superstar.

One could not be a Mole Person without paying a price, if only
because one cannot more or less subsist on drugs and not pay
a price. This would particularly have been the case with speed,
which gives those who live it a sense that they have no need to
either sleep or eat. Beautiful Freddy Herko, a dancer, exemplified
the Mole agenda, in that he had an immense sense of greatness,

accompanied by limited gifts. Ondine described him as "a total star dealing with space and time and dealing with his audience, and dealing with everything in that little thing called the avant-garde. But that was nowhere to go for Freddy Herko. Herko was involved in bigger things. He wanted to be seen. Fred Herko wanted to fly" (57). Somehow performing a minimally choreographed dance routine in the background of an avant-garde film, like Warhol's *Haircut*, while Billy Name cut someone's hair in the foreground, was insufficient glory for someone whose self-image was as vast as Herko's. The world ultimately closed in on him. A friend, seeing him dancing out of control on a restaurant counter, took him home. He bathed, then danced through an open window on the fifth floor as he listened to Mozart's Coronation Mass: fly he finally did. Andy famously said afterward that he wished he had been able to film Herko's death leap. But Herko's mind and soul had become entirely engaged with bead stringing, the Mole Person's defining occupation. Everyone knew that, in the value scheme of the Silver Factory, he had done the right thing.

Slightly older, and as manic as any Mole but probably too old to be a Mole Person herself, was Dorothy Podber, whom the Moles esteemed as a genius. She said, "I've been bad all my life. Playing dirty tricks on people is my specialty." Warhol wanted to put her into a film. Instead, she enacted a kind of happening, which was the crowning achievement of a life that lasted until her death in 2008. She turned up at the Silver Factory one day in leather pants and sunglasses, accompanied by her Great Dane.

Warhol was shooting a picture and was too preoccupied to talk with her. The story is frequently told. Podber asked if *she* could shoot some pictures, and Warhol said sure. She took a silver pistol from her belt, and sent a bullet through a stack of portraits of Marilyn Monroe, right between the eyes. Warhol exhibited them as "Shot Marilyns," but Dorothy Podber was persona non grata at the Silver Factory from that point on. The episode was inseparable from her life, and it was the main remembrance in her obituary.

Valerie Solanas, Warhol's failed assassin, was not a Mole Person. Her craziness was of another order. The new Factory—no longer the Silver Factory, since its shiny décor belonged to an era now past—was intended to screen out the kind of person the Mole People exemplified. By 1968, Warhol's inner administrative circle had changed. It now consisted of Fred Hughes, who sold Warhol's art at something like its market value, and who got portrait commissions for Andy, which he used to finance his movies; and Paul Morrissey, who more or less took over the filming and steered Warhol's movies into an increasingly narrative direction, beginning with *My Hustler*. Gerard Malanga was in disgrace, and Billy Name was more and more marginal, no longer clear what his mandate was in the new Factory, now that silver, in fact and in meaning, was passé. The day of the Mole People was largely past, much to Andy's regret after the assassination attempt: "I realized that it was just timing that nothing terrible had ever happened to any of us before now. Crazy people had always fascinated me be-

cause they were so creative. They were incapable of doing things normally. Usually they would never hurt anybody, they were just disturbed themselves; but how would I ever know again which was which?" (Bockris, 306).

The feminist theorist Ti-Grace Atkinson, at the time—June 3, 1968—president of the New York chapter of NOW, truly believed that no woman was crazy as such. If some woman behaved crazily, that was due, she felt, to something that had been done to the woman by some man. It was a feminist version of the liberal explanation of crime: that human beings are caused to be criminals by external, economic circumstances. Years later, she said, wryly, that Valerie Solanas taught her otherwise. She really was crazy to the core.

Solanas was an educated woman. She majored in psychology at the University of Maryland, where she came to the view that men were genetically defective, lacking a crucial chromosome. She was, or believed she was, sexually molested by her father, who administered oral sex when she was a child. She had a child when she was in high school.

Steven Watson, who wrote *Factory-Made: Warhol and the Sixties*, tracked down her high school yearbook, where she was praised for her brainpower and her spirit. Oddly, her views were not that different from Atkinson's: men were defective, not women. Solanas formed a society called SCUM—an acronym for "Society for Cutting Up Men"—and in a manifesto, unread until she became a celebrity, she explains on genetic grounds that society

would not be good until the men were eliminated. (That was not, of course, Atkinson's view.) She was a lesbian, and eked out a living by posing with other women, performing sex.

The story of her involvement with Warhol has frequently been told. In 1967, she phoned him, offering a film script with the title *Up Your Ass*, which proved to be too dirty even for him. He actually imagined that she may have been a female cop, engaged in an act of entrapment. He then seems to have lost the script. Solanas pestered him for money. Warhol's response was to offer her money for acting in his current film, *I, a Man*, in which she actually performed with considerable if gross wit. In any case, Solanas's resentment was not extinguished, and she persisted in her demands that the hopelessly lost script be returned. By June 3, she made up her mind to punish him. She waited for him to arrive at the new Factory, and even rode up in the elevator with him, wearing makeup and a heavy fleece-lined coat, with a handgun in each pocket. The heaviness of the coat was doubtless intended to disguise the presence of the weapons, rather than to call attention to itself, which of course it did. (A suspect in the London subway bombings was killed precisely because he was wearing an unseasonably heavy coat!)

No one in the Factory thought of Valerie as someone to be frightened of, which confirms Warhol's view that crazy people do not as a general rule do much harm to others. To any reasonable person, Valerie was just a nuisance. And Valerie made no threats, gave no warning. She merely opened fire, missing Warhol on the

first shot, then firing into his body when he threw himself under his desk. Valerie shot Mario Amayo, an art professional who lived part of the time in London, and she hesitated whether to shoot Fred Hughes. The elevator opened and Hughes said, "There's the elevator. Just leave!" And Valerie left, leaving chaos in the Factory, and uncertainty as to whether Warhol would live. She surrendered herself at seven that evening, to a traffic policeman. She shot Andy Warhol, she explained, because he had too much control over her life.

At her hearing, Solanas was praised by high-ranking feminists, like Atkinson, who called her the "first outstanding champion of women's rights." Atkinson came from southern aristocracy, and knew how to behave in high circles. Betty Friedan felt that she had left the New York chapter of NOW in good hands when she managed to get Atkinson elected president. She was a feminist revolutionary with elegant manners. So it came as a shock when Friedan read in the *New York Times* that Atkinson, speaking as the head of the chapter, defended Solanas in court. Valerie was unrepentant: she even demanded that Warhol pay her $20,000 for her papers. She spent the rest of her life in and out of prison and mental institutions, and said that she could always pursue Warhol again.

Warhol actually died—or was clinically dead—until brought back to life by open-heart massage.

Solanas's bullet could scarcely have done more harm: the bullet went in through his right side, passed through his lung,

ricocheted through his throat, gallbladder, liver, spleen, and intestines, leaving a huge hole in his left side. There are some famous images of his scars, by Richard Avedon and the great portraitist Alice Neel. Bobby Kennedy was assassinated the night of Valerie's arraignment, driving the attack on Andy off the front page. (Kennedy's assassination, along with the fatal shooting of Martin Luther King Jr. on April 4, gave the world the impression that everything was falling apart in 1968. That and the student riots in New York and Paris in April and May.)

Warhol spent part of his convalescence editing *Lonesome Cowboys*. Ironically, John Schlesinger's Academy Award–winning *Midnight Cowboy* appropriates some of Warhol's ideas, especially the romanticized idea of the hustler—and even incorporates what would have been seen as a "Warhol Party," actually using certain Warhol characters to play parts in it, with Viva playing the role of underground filmmaker. Morrissey made an underground parody of *Midnight Cowboy*, involving a hustler, and called it a tribute to John Ford. For a friendly moment, there was a dialogue between underground and Hollywood cinema, which in the end meant something to insiders, but it came to very little, mainly because the underground film movement was itself on the way out.

It is hardly matter for wonder that Warhol should have come through the experience a shaken man. He really feared a chance encounter with Valerie Solanas on the street. He poignantly said that he had never been afraid before, but that now he wasn't sure,

having gone through a death, whether he was really alive. "Like I can't say hello or good bye to people. Life's like a dream" (Bockris, 311). He was no longer allowed to take Obitrol, the appetite suppressant that was a mild amphetamine. Whether or not his giving up drugs at this point in his life explains things, it is widely conceded that the shooting marked a profound change in his life as an artist. He was a different person after dying, to put the matter somewhat surrealistically. That leaves the question that is impossible to answer, namely, how great a role in Warhol's art can we explain through even the mild level of amphetamines he took between 1961 and 1968? Since many in his circle were on amphetamines during those years, are we to say that the Age of Warhol is the Age of Speed? It does not help to say that he took so little and did so much—or perhaps it does. Billy Name took dilute amounts of the drug—and how much good did it do him? Subtracting the amphetamines leaves the difference between Warhol as a genius and Billy Name as muddlehead intact.

It is worth asking oneself how many other American artists would have made headlines had they been shot. The *New York Post* informed its readers that "Andy Warhol Fights for Life," on the assumption that its readers would know who was being talked about, and would have bought a copy of the paper to find out more. Of no other artist in America would this have been true. The *Post*'s readers would have known that he was the guy who painted *Campbell's Soup Cans*. Even if he had given up painting, he remained an artist in the public mind. The fact that he now

made movies instead of paintings meant that he was an artist who made movies. He had expanded the concept of the artist as someone who no longer limited his product to one particular medium. There would have been no other American artist of whom something like that was true. He really reinvented the concept of the artist as free to use whatever medium presented itself. Even the most creative artists lived conventional artists' lives in comparison with his. He persisted in his view that painting, in his own case at least, was a finished phase, without this meaning that he was not continuing to be an artist. He had simply found ways of continuing to be an artist who no longer painted. That did not mean that he felt comfortable about where he was, as Leo Castelli said about him. It just meant that feeling comfortable was no part of being an artist as he understood it.

In 1970, he discussed the idea of a traveling retrospective exhibition with the curator John Coplans of the Pasadena Museum of Art. It was to conclude its itinerary at the Whitney Museum of Art in spring 1971. He pointedly excluded from the retrospective what Donna di Salvo designated "Hand Painted Pop," which included the work that he showed a decade earlier in the window at Bonwit's. He wanted it to contain series only, like the soup can and the grocery boxes, the portraits of icons and the images of disasters, and, finally, the *Flower* paintings. It was as though, after all, he was what he said he wanted to be—a machine: a machine that produced not single works, but only series. So what was he to do now? In a way, Warhol seems to have sensed that the 1960s

were over, and that the decade newly entered upon was a kind of blank. In fairness, it must be said that no one quite seemed to know what was next. Painting, as people liked to say, was in trouble. Eric Fischl, a student in 1970 at Cal Arts, recalls that the faculty looked to the students to say where art was headed and what it should be. Drawing, for example, was frowned upon, though there was no clear sense of what was to take its place. Fischl described the atmosphere in what was one of the most advanced art schools of the time:

> It was about 1970, the peak of crazed liberal ideas about education and self-development. Do your own thing. No rules. No history. We had this drawing class that Allan Hacklin had put together. I arrived late. It started around nine or ten in the morning, but I couldn't get there until eleven. I walked into the studio and everybody was naked. Right! *Everybody* was naked. Half the people were covered with paint. They rolled around on the ground, on pieces of paper that they had torn off a roll. The two models were sitting in the corner absolutely still, bored to tears. Everybody else was throwing stuff around and had climbed up onto the roof and jumped into buckets of paint. It was an absolute zoo. [Kuspit, 33]

The art schools of America stopped, in effect, teaching skills. The assumption was that it was up to the students to somehow determine what kind of artists they would become. They would learn what they needed to in order to realize their ideas as art.

The art school "crit" replaced the course of instruction: the student defended his or her current work in a kind of consciousness-raising session. Everything was accepted so long as the student could justify it in a crit—everything, at least, except painting, which the decade impugned just as Warhol had done in 1965, and which seemed not to meet the needs of a new generation of artists, much of it now consisting of women, for whom painting was associated with the heavy machismo that Abstract Expressionist culture generated. Jackson Pollock's widow, Lee Krasner—herself of course a major figure in that movement, said, at the end of her career, according to sympathetic critic Anne Wagner, "I'm a product of this civilization, and, you might say that the whole civilization and culture is macho." The confession has the logical form of an enthymeme: a major and a minor premise, with an unstated conclusion, viz., "I, though a woman, am macho." As if she needed to be macho herself in order to survive as a painter. Women in the 1970s did not feel that way at all. In a major show of women artists in the mid-1980s, the subtitle of which was "Women Artists Enter the Mainstream," it was clear that the mainstream was something that was being reconstructed in such a way as to be more accommodating to what was believed to be a feminine sensibility. In the exhibition that Barbara Rose mounted of Krasner's work in the mid-1980s at the Museum of Modern Art, there were photographs of her paintings in her living space, with plants and patterned slipcovers. But in the MoMA show itself, the paintings themselves were in the flagrant

white cubes of its harsh galleries, as if an exhibition was an arena, and art a situation of ordeal, a rite of passage, that paintings had to be able to stand up against. The curator of painting, William Rubin, even stripped paintings of their frames! They had to brazen it out, like naked wrestlers in the gymnasium. Art had no place in life.

The increasing presence of women in the art force through the 1970s and after was not the only complicating factor in the art of that decade. There was also pressure from various racial and ethnic groups for recognition of their art by the defining institutions of the art world, most importantly by the museum. Multiculturalism inevitably diversified the curriculum of art history and the exhibitional programs of museums and galleries. The art world was growing into something that would barely have been recognized in the 1960s, let alone the 1950s, when Abstract Expressionism reigned supreme. It did not lack a logic, but the logic of art and of art appreciation became contested at every point, as more and more became allowed. In 1960 the great critic Clement Greenberg published an influential paper titled "Modernist Painting." Greenberg's thesis was that each art was beginning to inquire into what was essential to its defining medium. Greenberg thought that painting was becoming more and more pure, in the sense that it was more and more true to its essence. But the very reverse was to take place in the 1970s. A kind of "impurity" began to overtake artistic production. Warhol turned out to have been exceedingly advanced in this. He was the first contemporary

artist to consider wallpaper a legitimate artist's product. His "Silver Clouds" pioneered inflatable sculpture. Nothing could have been more heterogeneous then the "Exploding Plastic Inevitable," with music, dance, and film all mixed together and raised to the highest decibel. Painting would have seemed an entirely retrograde move for someone who emblematized advanced art. If, that is to say, Warhol was going to paint again, it was going to have to mean something different than painting had meant even in his own incredibly heterogeneous oeuvre.

Inasmuch as most speakers of the language think of easel paintings when they think of art, it is curious that this genre of painting has been deemed obsolescent by members of the avantgarde for much of the Modernist era. "Painting is washed up," Marcel Duchamp said to his companions Fernand Léger and Constantin Brancusi at an aeronautical exhibition in Paris in 1911, where they were admiring an airplane propeller: "Can you paint anything as beautiful as that?" Soviet artists after the Russian Revolution asked what role they were to play in the new society, for which painting was deemed unsuitable. The Mexican muralists denounced easel painting in favor of huge painted walls with heroic messages addressed to The People. In the early 1980s, heavy thinkers in the New York art world proclaimed the death of painting, as well as of the institution in which painting was mainly enshrined, namely the museum of fine art. But when it became evident in that era that, through a number of break-

throughs by Duchamp, Warhol, and Beuys, art could look like or be anything at all, it gradually became evident that there was no reason to exclude paintings from consideration, and in today's pluralistic art world, excluding paintings from major exhibitions like the Whitney Biennial seems merely curatorial caprice. The painting wars are over, leaving it a question of art-historical explanation why they ever raged at all. Though Warhol continued to make movies through the 1970s, he returned abruptly to painting in 1972, when he began a series of portraits of Chairman Mao in large numbers and in various sizes.

In February 1972, Mao Tse-tung encouraged President Nixon to visit China, and this was widely seen as a step toward easing the Cold War. Only someone with a solid anti-Communist reputation would have dared undertake this journey, and Nixon is credited with having made an exceedingly bold gesture. Warhol painted portraits of both these world historical figures. As described in chapter 4, Nixon is depicted with a green complexion and fangs, and the injunction "Vote for McGovern" is lettered along the bottom. The *Mao* paintings, by contrast, have a benign blandness, based on an exceedingly familiar image—the picture of Mao's features that was used as frontispiece of "The Little Red Book" of quotations from the leader of China in the role of sage. Warhol modified the image by making it look as if Mao is wearing lipstick and eye shadow, like (what I assume to be an allusion to) a raging queen. Warhol was often portrayed as a transvestite

in Chris Makos's photographs of him, and in a jocular interjection reported in Victor Bockris's biography, he says that lipstick for both men and women is one of the rights demanded in his film *Women in Revolt*, starring the three chief transvestites of the Silver Factory—Holly Woodlawn, Candy Darling, and Jackie Curtis.

Andy had a profound view on transvestism:

> Among other things, drag queens are ambulatory archives
> of ideal movie star womanhood. I'm fascinated by boys who
> spend their lives trying to be complete girls, because they
> have to work so hard—double time—getting rid of all the
> telltale male signs and drawing in all the female signs. I'm not
> saying it's not self-defeating and self-destructive, and I'm not
> saying it's not possibly the single most absurd thing a man
> can do with his life. What I'm saying is, it's very hard work to
> look like the complete opposite of what nature made you and
> then to be an imitation woman of what was only a fantasy
> woman in the first place. [Warhol and Hackett, 317–18]

Meanwhile, it is impossible to decide whether the *Mao* portraits are supposed to show him actually wearing lipstick, or if that is just a mannerism of his style of portraiture. My sense is that Warhol really did not see why men did not have the right to make themselves up to look better than nature made them, just as women do—and that he himself claimed that right by using makeup when he went out.

As with his popular *Flower* paintings, Warhol produced his *Mao* portraits in all sizes and prices, so that anyone could purchase a *Mao* painting to suit his means, including four giant *Mao*s, seventeen by thirteen feet, impressive enough to make a powerful statement at a rally in Tiananmen Square. As this is being written, the one remaining giant *Mao* in private hands has been sent to an auction in Hong Kong, where speculation is that it may bring $120 million, outselling Andy's *Green Car Crash*, which sold for over $80 million in 2007. But he also produced *Mao*s in small and medium sizes, and even printed rolls of wallpaper consisting of iterated *Mao*s. The Chairman's face was not simply silk-screened onto panels: Warhol enlivened the surface with spontaneous brushstrokes so that they had the look—they were hand-painted Pop.

The final transformation was astonishing. What Warhol had managed to do was to detoxify one of the most frightening political images of the time. Until Warhol appropriated Chairman Mao's face, to hang a picture of Chairman Mao was not merely to make a political statement. It was to make a declaration of faith. No institution in America would have faced the suspicion of subversion that hanging a portrait of China's most powerful radical leader entailed. It would be like hanging a portrait of Karl Marx or Joseph Stalin. Warhol managed to transform this awesome image into something innocuous and decorative. Anyone could hang one—or ten—*Mao*s without fear of offending anyone, or suggesting that he held dangerous and revolutionary ideas.

Imagine a young student, excited by the ideas that were taken up by the Red Guards in China, bringing home a poster of Chairman Mao to hang in his bedroom, being shown his parents' new Warhol—a benign portrait of *Mao* over the fireplace, next to one of Andy's soup cans, in a living room whose walls were covered in green and purple cow's-head wallpaper! Andy had a smallish *Mao* on his bed table in his town house on Sixty-sixth Street, off Madison Avenue.

Andy made approximately two thousand *Mao* portraits, restoring the Factory to something like the mass-production entity it had been for a time when he and Malanga were turning out hundreds of grocery boxes. But the imaginativeness of their variety of color and the mock impulsiveness of the brushstrokes was a preparation for the style of portraiture that was to become Andy's signature way of representing celebrities, and those who want to look like celebrities. There is room for serious scholarship addressed to the evolution of the Warhol portrait, which for a number of years became the economical basis of the Factory in its third and final phase, when potential subjects were invited to lunch in the paneled dining room of Andy Warhol Enterprises, after the end of the movie-studio phase of Warhol's career. It came to an end because Warhol and his associates were unable to get the money due them from a surprisingly successful run of an obscene remake of *Frankenstein* in 1973. Recently, I compared Warhol's portrait style with that of Francesco Clemente, also a portraitist of celebrities. As greatly as I admire Warhol

as an artist, however, I cannot imagine him having an interest in the kind of interiority that is Clemente's reason for portraying someone. He was a master and, to some degree, the servant of mechanical reproduction, lost, one might say, without some mediating recording instrument. By contrast, "I never paint a portrait from a photograph," Clemente says, "because a photograph doesn't give enough information about what the person feels." One might say that Warhol interposed his camera between himself and the subject precisely because only the surface engaged him. "When you sit for an hour and a half in front of somebody," Clemente observed, "he or she shows about twenty faces. And so it's this crazy chase of Which face? Which one is the one?" I think, in fairness, that Warhol would have said "all of them," refusing to choose. His screen tests, his arrays of photomat shots, were mechanical strategies for *not* making choices. But Clemente, a worldly man, finds ways of making visual what he knows about a person, in addition to what he sees. He translates this knowledge into visual inflections, presenting the subject in ways that could not be photographed. I know of few portraits in modern art that compare with his amazing *Princess Gloria von Thurn und Taxis*. The woman with the great name looks defiantly out over her stunning jeweled choker, aggressively wound around her neck, her fierce eyes enhanced by the green and pinkish tones Clemente has given her by way of a complexion. The portrait is inflected by stylistic discoveries independently made by Schiele, Beckmann, and Matisse, without in any sense being reducible to

them. By this painting alone he would be recognized as an artist of stature and authority. The features through which he creates the reality of Princess Gloria have no correspondences in the language of photography. Warhol's half-arbitrary colored shapes, placed where the defining features of a subject's face are shown, certainly don't correspond to anything photographic, mainly because they do not correspond to anything real in a person's face. That may account for the greatness of the *Mao* portraits. Do they tell us something Warhol intuited about the tyrant, e.g., that he dyed his hair black? Or wore lipstick to make himself more photogenic?

These questions do not especially arise with the other image that Warhol detoxified, namely the Communist crossed hammer and sickle emblem that a storekeeper would have thought about twice before displaying in his or her shop window. Andy exhibited his *Hammer and Sickle* paintings at the Leo Castelli gallery in January 1977, and later at Galerie Daniel Templon in Paris, which sold out. But the crossed hammer and sickle emblem was commonplace graffiti in Paris, where the Communist Party was strong, unlike in New York, where it was an incendiary mark, threatening and scary to a population that had been taught about the Cold War, and was persuaded that Communism was committed to the death of American values and all they stood for. True, the show was held in Soho rather than Omaha, but there were no demonstrations, no bricks through the window. Displaying the Communist logo a decade earlier would have

been as provocative a gesture as showing a plastic Jesus in art-
ist's pee in Richmond, Virginia. But it was like any Soho show
in that era. Andy had seen the Communist logo in Italy, where
he was something of a hero to the left. In 1975 he had shown a
series of black and Hispanic transvestites in Ferrara, which left-
wing critics praised as exposing the "cruel racism in the Ameri-
can Capitalist spirit, which left poor black and Hispanic boys
no choice but to prostitute themselves as transvestites." *Ladies
and Gentlemen*, as the suite was titled, really glamorized its sub-
ject, as suited the culture of transvestism: Warhol used patches
of color like collage, which scarcely goes with the political in-
tentions ascribed to the works. When Warhol was asked by the
press if he was a Communist, Warhol played dumb, asking Bob
Colacello if he was a Communist. Colacello said, well, he had just
done a portrait of Willy Brandt and was desperately seeking the
commission to portray Imelda Marcos, and Andy said, "That's
my answer." As a business artist, Andy did not let politics get in
the way. It was held against him that he pursued the shah of Iran
for a commission—but really so was *everyone* else after the shah's
money, since he was engaged in modernizing Iran, and inviting
professors to his country to help in that effort. I was invited to
lecture on contemporary art in Tehran, but the return of the aya-
tollah caused that to be indefinitely postponed. Italian capitalists
were Communists—Gianni Agnelli even bought a *Hammer and
Sickle* at Galerie Daniel Templon. Meanwhile, in Soho, everyone
was charmed: Paulette Goddard even thought she would have

a pin made—though it would be one thing to have it based on Andy's painting, another if it were a straightforward hammer and sickle. The striking fact is that the logo had gone dead in America—unlike the swastika, which even today arouses chills and anger. That of course does not mean that it has lost its energy elsewhere in the world. It maintains its toxin in North Korea, for example. But at least in Soho, in 1977, it could be shown with impunity. Sol Steinberg said that it was the one painting he wished he had thought of—a "political still life." In any case, since it is the rare case in which nobody gave Andy the idea of painting what had been a feared and hated mark, universally recognized, one has to give Andy credit for intuiting that Communism need no longer be something to think about with apprehension. Only twelve years later, the breaking of the Berlin Wall put an end to the Cold War.

Meanwhile, the four-panel portrait that Warhol more or less invented has an economic explanation. A one-panel portrait cost $25,000, but each subsequent panel cost substantially less, so that the fourth panel was $5,000. It was a considerable bargain, difficult to resist. Ultimately, Warhol's subjects were not celebrities but those who could afford to be painted as if they were celebrities, with the full four panels. I did meet one of his subjects, whose portrait, so she told me, was the last one he did. She said that he kept talking about her skin. Over and over he complimented her on her skin. If nothing else, it shows that his preoccupations of

the Bonwit Teller window remained with him throughout his life: his red nose, his pitted complexion, and whatever else it was that made his outward look a torment to him. In his book *The Philosophy of Andy Warhol* he wrote: "If someone asked me, 'What's your problem?' I'd have to say skin."

Andy Warhol Enterprises

It is often said that Valerie Solanas's attack was a dividing line in Andy Warhol's life, and that he became a different artist in consequence of the violence, which left him momentarily dead and permanently traumatized. There truly is a difference between the work before 1968 and what he did after his recovery. The first period really changed art history philosophically. It would be difficult to argue this for the latter period.

Counterfactuals are notoriously difficult to validate, but one cannot but wonder what Andy's artistic life would have been like had Valerie been a more easily mollified and less pathologically resentful person, who, despite her troubled personality, never fired a bullet. We can, I think, get some sense of how his life and his art would have evolved from the fact that, after all, she shot him six months after he had made the move to the Factory's sec-

ond venue, at 33 Union Square West, where from the beginning he was already on a new course. The move then was not merely a change of location. It was to be a new beginning. The silver décor of the first Factory had no place in the décor of his new studio, which was more like a functioning New York business office than a place where people made the scene. Fred Hughes and Paul Morrissey sought to make the new setup a far more effective, more businesslike operation. Morrissey had little patience with the kind of person that had given the Silver Factory its flavor and tried to screen out those whom he thought were the flakier figures. This was a matter of some concern to Warhol. "I was afraid that without the crazy druggy people around jabbering away and doing their insane things, I would lose my creativity. They'd been my total inspiration since 1964" (Bourdon, 313). And, of course, the new regime did not manage to keep Valerie Solanas from the door.

In some respects, Warhol could have been right about this. The shift between the two Factories made a major difference in the entire way the production of art was thought of, and hence in the kind of art it was. And that difference was already institutionalized at the beginning of 1968, months before Solanas pulled the trigger in early June. Andy had become an artist-executive who had begun thinking of art as a business, and the second Factory somehow emblematized this, with its businesslike aura, its glass-topped desks with their imposing business machines and telephones. He still thought of himself as someone who had retired

from painting in order to devote himself primarily to making movies. His lawyers were busy configuring Andy Warhol Enterprises as a legal corporate entity. If there were to be future paintings, they would legally be a product not of Andy Warhol the artist, but of Andy Warhol Enterprises, Incorporated, however this was to work itself out in practice.

In a way, the attack was good for business. His prices went up, for one thing, and so did his reputation. The brilliantly curated Pasadena retrospective, which defined his oeuvre, made clear how immense his contribution to contemporary art had been. So there were forces that pulled him back into the art world, where he was by now a fixed star, even though he clearly regarded the art selected for the Pasadena show as belonging to a closed corpus. But there were countervailing forces that pulled him in a different direction entirely. Andy's attitude toward the two parts of his business were, in my view, quite different. The movies were no longer in the genre of underground films. They were going to be expensive to make and needed crews and equipment very different indeed from the improvised setup involving a camera on a tripod, some lights, and whoever was standing around. He needed the facilities of Hollywood, or of Cinecitta in Rome. In a way, *Lonesome Cowboys* was the last real Silver Factory movie, and even it involved shooting on location. But new films were to open the door to the kind of life Andy wanted for himself—an international celebrity among the international celebrities—a star among the stars. Naturally, he expected the films to bring

in money. On the other hand, he needed to make art to pay the bills, though he would have stopped making art if he could have afforded to do so. That is pretty much what Warhol meant when he spoke of "business art," as he did in his 1975 *The Philosophy of Andy Warhol: From A to B and Back Again:* "Business art is the step that comes after Art. I started as a commercial artist, and I want to finish as a business artist. Being good in business is the most fascinating kind of art . . . making money is art and working is art, and good business is the best art." This seems exactly what Warhol had in mind when the move was made from the Silver Factory to Union Square West. He even envisioned selling shares of Andy Warhol Enterprises on Wall Street. So Valerie Solanas caused a glitch in the smooth realization of Warhol's overall plan when he changed locations.

As it turned out, the movies he made in the 1970s did not have the interest his earlier films had had, nor in the end were they financially successful. The "business art" of the 1970s and the 1980s, on the other hand, was touch-and-go, sometimes selling out, sometimes falling flat, though little of it had the overwhelming conceptual depth of the work he had done in the 1960s, when he wrought the changes that transfigured art history. To what degree that is due to its being business art is difficult to say. The *Mao* paintings, to be sure, were done in 1972, and the *Hammer and Sickle* paintings in 1977. These are commendable, even exciting, paintings, but they do not, as I see it, quite come to the same thing as "business art," though the *Mao* paintings made money

and the *Hammer and Sickle* paintings, "made for art," as Andy explained to Ronnie Cutrone, sold very poorly, at least at first.

As soon as Andy had the strength, he began to lead an intercontinental life of glitter and of glamour. As an artist, he found himself far more accepted in Europe than in America. In Europe, he was perceived as a very significant figure—as the artist of the Death and Disaster paintings, the cineaste who had made *Empire*—while in America he was still not taken as seriously as he deserved, and it was held against him that he had nothing to say about the war in Vietnam. In 1973, he was working with Paul Morrissey at Cinecitta making horror films for Carlo Ponti, going to parties, and becoming, if not an intimate then a confidant of such figures as Elizabeth Taylor. For a brief moment it even looked as if he would make enough money from these films to be able to forget "art." But when it came to business, he was no match for the Italians, and Andy Warhol Enterprises made nothing from its films on Frankenstein and Dracula.

By fall of 1974, despite the financial fiasco of the movies made in Rome, Andy Warhol Enterprises was installed in a third Factory—a classy suite of offices at 860 Broadway, with a company dining room where clients could be served lunch in style. The crazies had given way completely to executive types, each connected to some branch of Andy Warhol Enterprises. One part of it was his magazine, *Interview*, which brought in advertising revenues under Bob Colacello. Another part was the portrait business, run by Fred Hughes, who seemed to belong to the same social class

as those well enough off to commission portraits of themselves. 860 Broadway was furnished with some of the Art Deco trophies Andy had an eye for—he had entered a phase where he spent several hours each day shopping. Paul Morrissey had dropped out of the picture once it became clear that the expected fortune from the movies made in Rome would not be forthcoming. Andy Warhol Enterprises was mobilized to produce one last ill-advised movie, *Bad*, tailor-made for the punk sensibility that was sweeping youth culture at the time, with which Warhol's name and presence had somehow become associated. The high point of the film was a mother throwing her baby out a window—an episode that in terms of the movie code almost guaranteed that the film would fail. If Andy Warhol Enterprises made no money from the two films it produced in Cinecitta, it actually lost money with *Bad*. Finally, there was the business art, which he and Ronnie Cutrone made in the rooms set aside for it. He was, so far as the shape of his life and work is concerned, pretty much where he would have been had he not been shot.

This does not take into consideration the psychological scars Solanas's savage attack caused. But neither does it factor in the difference between the 1960s and the 1970s. The 1960s was a decade of movements, with Pop, Minimalism, and Conceptual art defining the discourse. There were no movements to speak of in the 1970s, and no historical direction. "What happened in the Seventies?" Roy Lichtenstein asked when the decade was over, implying that the answer was "Nothing." This is extreme. Artists

did emerge, especially in photography. There was Cindy Sherman, Nan Goldin, and Robert Mapplethorpe. But the pluralism that overtook the art world had set in. Each artist had to find his or her own way. The shape of art history had changed radically, due as much to Warhol's achievements in the 1960s as to anything else. Like every other artist, he was on his own.

Before he became a business artist, Warhol was clearly interested in fame, but money seemed somehow a secondary aim. He hoped people would buy the grocery boxes, but they didn't. He may have hoped that the Death and Disaster paintings would sell, but few were much interested in them, at least in America, and whatever mild interest that was generated in them did not result in sales. Taken as a whole, the body of work that made up the Pasadena retrospective presented what one might call Andy Warhol's philosophy of life. He represented the world that Americans lived in by holding a mirror up to it, so that they could see themselves in its reflection. It was a world that was largely predictable through its repetitions, one day like another, but that orderliness could be dashed to pieces by crashes and outbreaks that are our nightmares: accidents and unforeseen dangers that make the evening news and then, except for those immediately affected by them, get replaced by other horrors that the newspapers are glad to illustrate with images of torn bodies and shattered lives. It is a world of little people—us—with the imperfections that gnaw at us and explain why we are not loved the way we would like to be, but imperfections that afflict even the stars and the celeb-

rities who take their own lives, even though we envy them for their beauty, their success, their supposed happiness. Andy had a prurient side as well, a kind of giggling voyeurism, wanting to see our cocks and our anuses and our breasts, to take pictures of them, and to make movies in which people grope at one another's bodies and try to be satisfying to one another, but who fail as often as they succeed. Hollywood treats us as if we were children. It does not give us what we want to see. "Movies should be prurient. Prurience is part of the machine," he told an interviewer (Bourdon, 327). It is OK as an artist to make paintings by peeing on treated canvases, smirking when viewers, ignorant of their origin, find them beautiful as abstractions. It is OK to make drawings of genitalia, as long as we tell others to think of them as abstract. In his own way, Andy did for American society what Norman Rockwell had done. America, and especially New York, had become the center of the art world. American art was admired and imitated everywhere. But what was so American about it? Andy painted S&H green stamps. He painted American currency in small denominations. He painted what Americans eat. People felt that he was one of them, even when he talked about business art being the best art.

But what he actually produced as business art rarely seemed to belong to that picture. Typically it consisted in a suite of prints (and of paintings) made for money. When he painted the soup cans, people widely felt that no one in their right minds would buy them. But handsome images of famous athletes and endan-

gered species seemed made to order for the waiting room walls of successful professionals or the lobbies of expensive hotels. The business art seemed made for the sake of business.

Occasionally, as a business artist, Warhol did something as deep as he had done before. In a wonderful suite of prints, commissioned by the Ronald Feldman Gallery, the images were drawn entirely from popular culture: a movie star (perhaps Elizabeth Taylor as Cleopatra), Superman and Mickey Mouse and Santa Claus as forces of good, Dracula and the Wicked Witch of the West as forces of darkness, Uncle Sam as ambiguous as between goodness and wickedness, Aunt Jemima as the emblem of our daily bread, and, of course, Andy himself as the Shadow, who sees all and knows all. He even included Howdy Doody, that gawky, freckled doofus that the younger generation knew so well from a children's program they watched in their suburban living rooms, singing along with him and his older friend Buffalo Bob. I was reminded of how the youthful revolutionaries at my university had actually gone to see Howdy Doody perform on campus, in the midst of their uprising, and sang together with him and one another the songs they remembered from their childhood when the responsibility for making a better world had not yet fallen upon their shoulders. It was characteristic of Andy that he should have asked, when they were making the photograph of Howdy Doody he was going to use for his print, whether Howdy Doody had a penis. According to Ronald Feldman, they undressed Howdy Doody there and then, in the studio, and sure enough, there was

a wooden stub that proved that the effigy was one with the rest of us when it came to the normal bodily parts that keep us excited and aware of the bodies of others. But he did not show Howdy Doody naked. That was not part of the myth.

Had Warhol painted a dollar sign as a further myth, everyone would have seen what he was getting at. We are all preoccupied with money, and, in its way, the plain unvarnished dollar sign is as much an emblem of America as the flag. There is even a widely repeated textbook account of the origins of the dollar sign, namely that it was a monogram for the United States, with a "U" superposed over an "S." That would account for the two vertical lines and the necessary cuts—but it leaves an embarrassing problem of dollar signs with single lines, and it has no convincing way of explaining the loss of the "U"'s curved bottom, which must already have disappeared when the dollar sign first appeared in print, in 1797. The curve would have had to vanish even earlier: Jefferson used it in a memorandum of 1784, in which he recommended the dollar as the chief unit of American currency. It can hardly be believed that the "U" could have lost its bottom so soon after American independence! There are deep historical reasons why the dollar sign could not conceivably have descended from a monogram for the United States, but I am stressing only the point that the dollar sign could as readily have been one of the American myths as, say, Uncle Sam ("U.S.").

But critics found it difficult to grasp what Andy was getting at when he mounted a show at Castelli in 1981 of drawings, prints,

and paintings of dollar signs, which may have seemed, too liter-
ally, to have been a show of business art. The critics' grumbling
notwithstanding, the *Dollar Signs* are marvelously inventive.
Sometimes Warhol compiled a sort of anthology of his varia-
tions within a single frame—twenty dollar signs in four rows, no
two alike, some as fat and impulsive as Chinese ideograms; some
curved and elegant, like something executed by a master of italic
script; some sans serif and others with ornamental termini. It is
very much as if he meant to demonstrate that he was as interested
in the possibilities of the sign itself as in what it stood for—as
if he were submitting designs for the dollar sign, and showing
us various ways of drawing it. The variations could be endless.
There was a kind of gaiety in the show, notwithstanding the criti-
cal response, which was dour and sour, as if Warhol were taking
liberties with a sacred symbol. The show was also a failure finan-
cially; not one painting sold. The *Dollar Sign* paintings flopped
as badly as the Death and Disaster paintings in the 1960s, mainly,
I think, because they were perceived as frivolous.

Somehow, everything about the show seemed to reflect the
fact that it was a corporate endeavor. Cutrone, who installed the
show, alternated the *Dollar Signs* with images that Warhol had
done of knives and revolvers—the same pistol, according to his
account, that Solanas had shot him with. Fred Hughes said that
this display looked too European, that the show should just be of
Dollar Signs. He was correct, as no one was interested in this part
of the show. The handgun is somehow too charged an emblem

for someone to say, as Emile de Antonio said of Coca-Cola, that it is who we are—even if the Second Amendment is a hot political issue, and despite the fact that the Saturday night special is part of the American scene. Everyone can understand why Warhol might have painted what is, after all, associated with the most traumatic episode of his life. But for just this reason, it seems to me, it does not belong with his vision of the world. People would feel uncomfortable with it. It would not be part of what gives meaning to our lives as Americans. Its meaning would be too private and too autobiographical for someone who was so public an artist—so much the artist laureate of the American soul, for which Warhol in his prebusiness phase seemed to have such perfect pitch. That is something he seems to have lost, or to have found only intermittently in the 1970s. That is why the Feldman show was so successful—the symbols belonged to everyone. Somehow, it seems to me, the *Dollar Signs* are too decorative and too playful. They would make good designs for sophisticated shower curtains, or even wallpaper, but for something that verges on a national symbol, they seem too shallow.

A work that seems far too personal to have been business art is an installation of paintings of shadows that Warhol and Cutrone executed in 1978. As with the *Hammer and Sickle* paintings of the previous year, they seem to belong to an impulse that Warhol should do something that would have a purity as art—something that really meant something—the way shadow implies substance without being substantial in its own right. They are abstract

while at the same time representational, though what they represent remains a central question in Warhol interpretation. Shadows play a certain role in mythological accounts of the origin of drawing. A Corinthian girl is said to have drawn around the edge of her lover's shadow cast by firelight on the wall, creating a silhouette of his profile. Warhol's shadows are more abstract. They are cast by objects that have no obvious specific identity, though Bob Colacello claims that they are shadows of erect penises—erect *uncircumcised* penises, one would want to specify, to account for the blip at the tip. That would be consistent, certainly, with Warhol's irrepressible prurience, but somehow inconsistent with what one takes to be the aesthetic agenda of the space he must have visualized for them. But they could as easily be of eggplants or cucumbers, or, as someone has proposed, the Empire State Building. Or they could be of outcroppings of rock in a desert—or lunar—landscape.

The likelihood of some identifiable object to which the shadows in these paintings refer is probably slight. Andy wanted to make some abstract paintings, according to Cutrone's recollection, mainly because he came from a generation of artists who resisted abstraction when the general view was that real painting must now be abstract, that abstraction's time had come in a revolutionary way, and resisting the revolution was inconsistent with the true impulse of art history. Artists in my generation, as in Warhol's, felt a twinge of guilt in doing figurative art. Jackson Pollock castigated de Kooning as reactionary for painting

women in 1952 in his landmark exhibition at the Janis Gallery. Cutrone said to Warhol, according to his recollection, that he was from a later generation and had no such hang-ups. It was he who proposed painting shadows of forms that were not forms *of* anything—whose resemblances to anything would be purely coincidental, unlike one's lover's profile.

The *Shadow* paintings do have the somewhat mysterious look of twilit abstract landscapes, with what one might call "decorator colors"—aubergine, Klein blue, chartreuse. The Dia Foundation purchased eighty of them, which are today installed in a large dedicated room as a single integral environment, one abutting another, and all hung very close to the floor, at the Foundation's space in Beacon, New York. So placed, Warhol's *Shadow* paintings fit the identifiable spirit of Dia, which has favored art of a marked spirituality, such as the nearby monument by Blinky Palermo *To the People of New York City*, made up of several components in the colors of the German flag. Or, for that matter, of the general feelings one imagines the Foundation aspires to achieve through the work of Fred Sandbeck, Dan Flavin, Robert Ryman, or Donald Judd—a kind of elevating mystical abstraction that lifts the spirit onto a plane of communion with higher forces. It is, as I say, not what one would think of as business art. But nor is it what one thinks of as Warholian art. There is nothing brash about it, nothing that presses against the envelope in ways one expects from Warhol. It is like a wish come true for someone who respects and admired Warhol as a serious artist, but who

longs to see him produce a piece of art of high spirituality. Far closer to Warhol would be the roomful of silk-screened *Last Suppers*, based on a cheap color reproduction, with double Jesuses and price tags, that he did in his last years.

The art produced by Andy Warhol Enterprises consists of the portraits, and then, mainly, the suites of prints dreamt up as commercial propositions, like the athletes, or the endangered animals. The *Shadow* paintings brought in $1.6 million—something of a steal, everything considered, in a class with the sale of all the original *Campbell's Soup Can* paintings for $1,000.

Religion and Common Experience

Andy had, by nature, a philosophical mind. Many of his most important works are like answers to philosophical questions, or solutions to philosophical puzzles. Much of this is lost on many viewers of his work, since philosophy itself is not widely cultivated outside universities, but in truth most of the philosophical knowledge needed to appreciate Warhol's stunning contributions did not exist until he made the art in question. Much of modern aesthetics is more or less a response to Warhol's challenges, so in an important sense he really was doing philosophy by doing the art that made him famous. In other words, most of the philosophy written about art before Warhol was of scant value in dealing with his work: philosophical writings could not have been written with art like his in mind, as such work simply did not exist before he created it. Warhol demonstrated by means of his *Brillo Box* the

possibility that two things may appear outwardly the same and yet be not only different but momentously different. Its significance for the philosophy of art was that we can be in the presence of art without realizing it, wrongly expecting that its being art must make some immense *visual* difference. How many visitors to his second show at the Stable Gallery wondered if they had not mistaken the address and walked into a supermarket stockroom? How many, walking into a theater in which the film *Empire* was being shown, thought that they were looking at a still image from a film that had yet to begin its showing?

Something similar can be true as well of certain religious objects, which we expect to look momentously different from ordinary things but which are disguised, one might say, by their ordinariness. Of the four vessels today claimed to be the Holy Grail, for example, the one that most persuades me that it might be genuine is an ordinary-looking vessel, drably colored, rather like an individual salad bowl, in a vitrine in the cathedral of Valencia in Spain. It really looks like something Jesus could have used at the table, given that he affected the life of the simple persons he lived among—carpenters and fishermen and the like. Of course, as befits so venerated an object, the *Sacra Cáliz*, as it is called, is supported by an ornate and gilded stand embellished with pearls and emeralds, but if one saw it by itself, it would be unprepossessingly plain, though it is carved out of a piece of stone. The Grail would not have been on so ornate and precious a stand at the Last Supper itself, where it was actually used for whatever was

eaten on that tremendous occasion, touched with the lips or the fingers of who those present were certain was the Messiah. Jesus himself was like that bowl, if indeed, the claim is true that he was God in human form. Imagine that there was a man just his age in Jerusalem, who looked enough like Jesus that the two were often confused for one another, even by those who knew them well. The difference could not have been more momentous than that! Confusing a god with a mere human being is, *toutes proportions gardées*, like confusing a work of art with a mere real thing—a thing defined through its meaning with a thing defined through its use. Imagine a student who has followed a program of institutional critique whose thesis consists of substituting in a museum display an ordinary Brillo box for one of Andy's—a work worth $2 million at Christie's in exchange for a mere cardboard box of no greater value than that of the material of which it is made.

Relics are typically presented the way the *Sacra Cáliz* is in Valencia today—a fragment of bone is placed in a golden housing, set with priceless stones and perhaps images of the saint to whom the bone is believed to have belonged. One has to take it on faith that the bone is the bearer of special powers, but in the nature of the case it must look like a mere human remnant, and be able to pass all the obvious tests, like DNA assay. It is felt that the Grail must have extraordinary powers, given the belief that it was touched by God incarnate, but the history ascribed to the Grail, if it really still exists, has left no traces on its surfaces. That it was touched by Christ's lips, that it held Christ's blood, cannot be

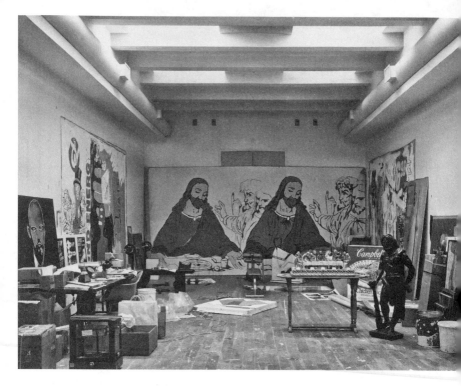

Andy's last studio, just as he left it, 1987. Photograph by Evelyn Hofer, New York

deduced from anything the eye now sees. Its plainness alone tes-
tifies to the possibility that it was present at the last meal Christ
shared with his disciples, where it looked like an ordinary dish,
maybe a little special given the special character of he who used
it. But the test for whether Jesus was God embodied is not part
of the forensic repertoire. The Transfiguration described in the
Synoptic Gospels was intended to show selected disciples that
Jesus transcended the merely human, for example, by his radi-

ance. But the so-called Messianic Secret was meant to be kept quiet—Jesus preferred not to be trooped after by groupies thirsting for miracles. For anyone other than witnesses to the Transfiguration, Jesus was out and out human.

I respond deeply to a description of Christ's humanity by the great art critic Roger Fry in regards to a painting by Mantegna, now in Berlin: "The wizened face, the creased and crumpled flesh of a newborn babe . . . all the penalty, the humiliation, almost the squalor attendant upon being 'made flesh' are marked." To paint God incarnate, the Christian artist need paint only a human being. Of course there were eternal indications, like halos, that represented the other aspect. But these would be mere symbols, the way gold frames symbolize that they protect works of art. Bleeding is evidence of being human, but there is no such simple evidence of divinity.

I have plunged into certain religious matters because of a thought of the philosopher Hegel, who said that philosophy, art, and religion are what he called the "moments" of Absolute Spirit. I offer this because it suggests that art, philosophy, and religion are forms through which human beings represent what it means to be human. One of the things that is distinctive of human beings is that the question of what it is to be human arises for us in a way that it doesn't for other animals. There is, in that respect at least, an analogy between artworks and religious objects, and that may be a way to approach the question of whether and in what way Warhol's art actually is religious. What is undeniable, of course,

is that he was a Catholic, whose mother was quite pious, and that he and his mother prayed together, at home and in church. After her death he continued to attend Mass. In truth, most of those who frequented the Silver Factory were born and raised Catholics, including most of the Mole people. The critic Eleanor Heartney, herself Catholic, has written a very searching study, *Postmodern Heretics*, in which she describes "The Catholic Imagination in Contemporary Art," to use her subtitle. A great deal of the content of contemporary art in America involves aspects of the human body that imply Catholic attitudes, but these aspects at the same time are offensive to a conservative Catholic morality. A good example is Andres Serrano's incendiary *Piss Christ*, in which a plastic crucifix is displayed in a container of the artist's urine. This caused an immense uproar when it was exhibited in the Richmond, Virginia, Museum of Art. Serrano is Catholic, and it is not difficult to see that he was vividly depicting the way in which Christ was "despised and rejected," to quote Handel's *Messiah*—jeered, spat upon, hit. Pissing on someone is conspicuously humiliating and degrading. Urine and spit are heavily laden with contempt, as feces or vomit would be, or menses. In my view, Serrano was seeking to restore the way Jesus was humiliated as he carried the cross to Golgotha. To be sure, it was a plastic effigy—but what difference does that make? Is the crucifix not an object of worship as much so as the person crucified? When Barnett Newman, a Jew, painted the Stations of the Cross, he did so in a very abstract and what one might call interior way. It is

about unendurable pain, fainting, and giving up the ghost. But it offends no one, the way Serrano's piece certainly does. Years ago, I quoted one of Yeats's "Crazy Jane" poems to a member of the so-called Moral Majority when we were both on a panel charged to discuss the National Endowment for the Arts and the highly sexual work of the photographer Robert Mapplethorpe: "Love has pitched his mansion in the place of excrement." He replied that it was hardly Yeats's finest line, and I asked him to quote me a finer one. Crazy Jane was one of Yeats's inspired inventions for addressing the sexed body and the physical basis of human love.

Warhol did not particularly like to be touched, especially by women, according to Viva, but he certainly had a kind of gleeful curiosity about sex and sexual parts, and made a point of showing it in his art, especially in his movies. Whether this can be explained by his Catholicism is hard to say. But nothing more sharply distinguishes the art of the 1950s from that of the 1960s in New York than the difference in how death and sex are represented in the two decades. Robert Motherwell—a Protestant— painted the great series of abstract canvases under the title *Elegy for the Spanish Republic*. Serrano showed cadavers in a morgue. De Kooning's great paintings of women in 1952 were daringly misogynist, with their heavy breasts and bared teeth. Mapplethorpe photographed huge penises, or fists pushed into assholes. The fact that painting gave way to photography in the 1970s has to be crucial in how the same subject would be addressed. Andy tried to exhibit drawings of nude boys at the Tanager Gallery

on Third Street, where they were rejected on principle, though Andy's drawings were never as robust as his silk screens. Abstraction can, as easily as not, be understood as a form of repression, which can then make Pop seem itself a form of liberation. But the sexual revolution of the 1960s was bound to show up in art as well as life, without this necessarily meaning that the artists whose work took on sexual content were especially catholic. It was a change in the culture. Most of the facts affecting Andy's religiousness belong to his biography. But none of this shows that Warhol was especially religious in his art.

Let us consider his last substantial body of paintings, based on Leonardo's *The Last Supper*, which are thought by some to be evidence of Andy Warhol's religiousness. As so often happened in Warhol's work, the idea came from elsewhere, in this case from the dealer Alexandre Iolas, who had a gallery in Milan. Andy was one of five painters he selected to do paintings based on Leonardo's *The Last Supper*. His idea was that a show of Last Suppers by contemporary artists would generate interest, since the gallery was across the piazza from where Leonardo's masterpiece was undergoing its latest restorations, and there would have been an incentive for visitors to take in both it and versions of it by painters of our day. Warhol specialists have observed that he found the reproductions of *The Last Supper* in art books too dark, explaining why he used cheap copies of the old painting instead. But in my view, what is important about the fact that the original is Leonardo is that *everyone knows Leonardo's painting*—it belongs

to the common consciousness of the culture that Warhol shared with everyone who knew his work, and which he took as his artistic mission to raise to self-awareness—to show our inner life to ourselves. Leonardo's *The Last Supper* is one of the few paintings that enjoys this status—Warhol's can of Campbell's tomato soup is another—though few of those who know *The Last Supper* ever actually saw it in Milan; it is better known through its many reproductions. To show *The Last Supper* as commonplace is to show it as it appears on a postcard, the way Duchamp showed the *Mona Lisa*, or in a calendar of masterpieces. Ask people to name ten paintings, they will inevitably name *The Last Supper*—not *La Conversation* of Matisse, let alone *The Last Sacrament of Saint Jerome* by Domenichino or one of the Mont Sainte-Victoire landscapes by Cézanne.

Andy treated the Last Supper as he treated many of his subjects. He did versions that showed series of *Last Suppers*, much like his serial paintings of soup cans or dollar bills. He doubled Jesus, the way he doubled Marilyn, or Elvis. Repetition was a sign of significance. He filled it with logos from contemporary products, like Dove soap, to represent the Holy Spirit, or the Wise owl from the familiar potato chip package, emblematizing wisdom. Or he used the General Electric logo to emblematize light. All these came from the commercial world in which he and the rest of us are at home, though it is fair to say that none of them held religious significance as such. Warhol's great artistic project began with the images in the Bonwit Teller window and evolved

on two levels—the level of fears and agonies, and the level of beauties. The level of plane crashes, suicides, accidents, executions; and the level of Marilyn, Liz, Jackie, Elvis, Jesus, radiant with glamour and celebrity. A dark world with radiant beings, whose presence among us is redemptive, and into whose company Warhol sought to insinuate his own ungainly presence, and to make stars of us all. His mission was to externalize the interiority of our shared world. *The Last Supper* has penetrated the common consciousness with the momentousness of its message. In making it his, he too has become part of what we are. And by making it his he shows us that it is ours, part of life, rather than something one has to travel to Italy to see—in this respect it is like the dish sometimes held to be the Grail, commonplace rather than rare, a dish like any other rather than something crusted with jewels and made of precious metals. Or, like his own early prints, something that one could buy for a few dollars at the receptionist's counter at Castelli's, where they were displayed in stacks. A genuine work of art for five bucks! No wonder he stenciled low price tags—like $6.99—on pictures of masterpieces.

The painting that most clearly alludes to the hiddenness of religious truth is perhaps Warhol's *Camouflage Last Supper*, where the visual message of the painting is distorted by an overlay of visual noise. Warhol began to use camouflage in 1986, the same year in which he did his *Last Suppers*, and used it as well in connection with his own self-portrait, in which it carries something like the same meaning it does in *Camouflage Last Supper*: it reveals

the hiddenness of his own truth, which is all on the surface. He famously said, "If you want to know all about Andy Warhol, just look at the surface: of my paintings and films and me, and there I am. There's nothing behind it." He even did a series of works consisting of nothing but camouflage, which as a visible pattern had become as ordinary and as everyday as violence itself in the modern world, however unusual its appearance in art—as unusual as *Brillo Boxes* in art galleries would have been in 1964, for that matter. Critics saw the camouflage works as ready-made abstractions, but what they mean is that their subject is completely hidden. The camouflage swatch has in fact become the portrait of the political reality of our time, too horrifying to look upon directly. The inference, on seeing someone wearing camouflage, that it is a solder is based on a social truth that camouflages, is the visible mark of the military in our time.

My feeling is that the hiddenness implied by camouflage belongs with the idea that confidences were disclosed at the Last Supper. What meaning could be more secret than that the wine and bread are Christ's flesh and blood, and that in partaking of these Jesus becomes part of the blood and flesh of the partakers? But I do not think Warhol became a religious artist in the last years of his life, with the *Last Supper* paintings.

I think the religious turn, if there was one, happened much earlier. I believe that at some moment between 1959 and 1961 Andy Warhol underwent an artistic change deep enough to bear comparison with a religious conversion—too deep, one might

say, not to be a religious conversion. Before then, his work had a certain effete charm, consisting of plump cherubs, posies, pink and blue butterflies, pussycats in confectionary colors. He made a handsome living as a commercial artist, whose chief product consisted of playfully erotic advertisements for upscale ladies' footwear. My feeling is that his religious identity was disclosed in April 1961, in his first exhibition—installed, symbolically, in a site displaying soft fluttery summery resort wear for the class of women for whom the luxurious shoes that had given him his first success were designed—the windows of Bonwit Teller, one of the great emporia for upscale women's clothing on Fifth Avenue in New York. Warhol, as we saw, surrounded the mannequins with blowups of the coarse, grainy advertisements one sees in the back pages of cheap newsprint blue-collar publications. The images he appropriated after the conversion were vernacular, familiar, and anonymous. They typically advertise cures. A montage of black-and-white newspaper ads is for falling hair; for acquiring strong arms and broad shoulders; for nose reshaping; for prosthetic aids for rupture; for love elixir ("Make him want you"); and for Pepsi-Cola ("No Finer Drink"). It projects a vision of human beings as deficient and as needy. It was a message not unlike that of Josef Beuys, whose symbols were fat and felt, to minister to the hungry and the cold. All religion is based on suffering and its radical relief. It was as if the message of saviors had been translated into the universal language of cheap American advertisements. The Bonwit Teller show testifies to what remains per-

haps the most mysterious transformation in the history of artistic creativity—Warhol's "before and after."

In a great photograph of Warhol's studio taken by Evelyn Hofer just after his death, there is a large painting, on the far wall, of a double portrait of Jesus presiding at the Last Supper, his eyes cast down, while two disciples, Thomas and James, gesture with great animation to his left. In that studio photograph, many other paintings are shown, leaning against the side walls. The only other picture that faces us, however, is on the left of the painting I have been discussing. It shows a bowl of chicken noodle soup blazoned on the familiar red and white Campbell's soup label, with the familiar logo, the neatly written *Campbell's.* The image on the label is of a mass-produced china dish, whose utterly commonplace decorated rim rings the Queen of Soups like a halo. I find it affecting that the two images—*Campbell's Soup Can* and *Last Supper*—mark the beginning and the end of Warhol's career—at least, once he found his way. But I find it no less affecting that the plate on the label echoes the plate on the table, at which Jesus appears to be gazing with his downcast eyes, as if the plate embodies some profound meaning. I imagine Warhol, standing before the two paintings, at the final moment he was to spend in his studio, looking at both the dishes as if they were cognate Grails.

What his final thought as an artist was, of course, is impossible to say, but I like to think that it has to have been about two dishes, one empty, the other full of our daily soup, warm, hot, filling,

tasty, like the answer to a prayer. The two paintings together reveal his calling as an artist. He is *grateful* for the daily bread asked for in the Lord's Prayer. Meanwhile, he was in terrible pain from gallstones, for which he knew and feared that he would soon require an operation. The trip to Milan for the Last Supper show had been physically agonizing. The second and last death struck him on February 22, 1987, at New York Hospital. He died peacefully and to the surprise of everyone.

Bibliography

The Andy Warhol Catalogue Raisonné. Vol. 1: *Paintings and Sculptures, 1961–1963.* Vol. 2: *Paintings and Sculptures, 1964–1969.* Edited by Georg Frei and Neil Printz. New York: Phaidon, 2004.

Andy Warhol Prints: A Catalogue Raisonné 1962–1987. Edited by Frayda Feldman and Jorge Schellman. 3rd ed. New York: DAP, 1997.

Andy Warhol: A Retrospective. Edited by Kynaston McShine. New York: Museum of Modern Art, 1989.

Angell, Callie. *Andy Warhol Screen Tests: The Films of Andy Warhol—Catalogue Raisonné.* New York: Harry N. Abrams, 2006.

———. "Andy Warhol, Filmmaker." In *The Andy Warhol Museum.* Pittsburgh: The Museum, 1994 (121–45).

Bockris, Victor. *Warhol: The Biography.* New York: Da Capo. 2003.

Bourdon, David. *Warhol.* New York: Harry N. Abrams, 1989.

Cabanne, Pierre. *Dialogues with Marcel Duchamp.* New York: Da Capo, 1971.

Colacello, Bob. *Holy Terror: Andy Warhol Close Up.* New York: HarperCollins, 1990.

Danto, Arthur C. "The Philosopher as Andy Warhol." In *The Andy Warhol Museum.* Pittsburgh: The Museum, 1994 (73–90).

———. *The Transfiguration of the Commonplace: A Philosophy of Art.* Cambridge, MA: Harvard University Press, 1981.

————. "The Artworld." *Journal of Philosophy* 61, no. 19 (Oct. 15, 1964): 571–84.

Dillenberger, Jane. *The Religious Art of Andy Warhol*. New York: Continuum, 1998.

Duchamp, Marcel. "A Propos of 'Readymades'" (lecture at the Museum of Modern Art, 1961). In *Theories and Documents of Contemporary Art: A Sourcebook of Artists' Writings*. Edited by Kristine Stiles and Peter Selz. Berkeley, CA: University of California Press, 1996.

Giorno, John. "Andy Warhol's Movie *Sleep*." In *You Got to Burn to Shine: New and Selected Writings*. London and New York: High Risk/Serpent's Tail, 1994 (122–63).

Hegel, G. W. F. *The Phenomenology of Mind*. Translated by J. B. Baillie. London: George Allen and Unwin; New York: Macmillan, 1949.

Janowitz, Tama. *Slaves of New York: Stories*. New York: Crown, 1986.

Kuspit, Donald. *Fischl*. New York: Vintage, 1987.

Malanga, Gerard. *Archiving Andy Warhol*. Creation, 2002.

Motyl, Alexander J. *Who Killed Andrei Warhol?* Santa Ana, CA: Seven Locks, 2007.

Steinberg, Leo. *Other Criteria: Confrontations with Twentieth-Century Art*. Oxford: Oxford University Press, 1972.

Warhol, Andy. *The Philosophy of Andy Warhol: From A to B and Back Again*. San Diego, CA: Harcourt, Brace, Jovanovich, 1975.

————. *A: A Novel*. New York: Grove, 1968.

Warhol, Andy, and Pat Hackett. *POPism: The Warhol '60s*. San Diego, CA: Harcourt, Brace, Jovanovich, 1990.

Warhol from the Sonnabend Collections. New York: Gagosian, 2009.

Watson, Steven. *Factory-Made: Warhol and the Sixties*. New York: Phaidon, 2003.

Woronov, Mary. *Swimming Underground: My Years in the Warhol Factory*. London: High Risk/Serpent's Tail, 1995.

Index

Page numbers in italics refer to illustrations.

Index

Velvet Underground, The, rock
group, 7–8, 77
Vietnam war, 124
Vile, Ronnie, 95–96
Viva, 80, 84, 104, 141
von Thurn und Taxis, Princess
Gloria, 115–116

Ward, Eleanor, 35, 70–71
Warhol (Bockris), 1, 6
Warhol, Andy, 1, *63*; Abstract Ex-
pressionism and, 8–9, 14, 58;
aesthetic, 12–13, 29–30, 34, 49–50,
55–56, 60, 83, 86, 132, 135; Art
Deco collected by, xvi, 125; as
artist-executive, 121; art world
and, 4, 25–26, 35, 124; attempted
assassination of, 100–101, 102–105,
120, 122, 125; as avant-garde artist,
2, 3, 81, 82, 85; business art of, 117,
122–123, 125, 127–128, 130, 131, 133;
cameras used by, 76, 77, 79, 82–83,
85, 87–89, 115, 122; camouflage
works, 145; capitalist production
and, xii; celebrity of, 47, 85–86;
childhood poverty of, 57–58; as
commercial artist, xiv, 2, 3–4, 8,
12–13, 16, 143, 146; conception of
art, 51; criticism of works, 15, 26,
45, 67, 72–73, 97, 130; as critic of
American culture, x–xi; as culture
and art icon, x, xii, xiv–xv, 1, 2,
3, 4–5, 6, 8, 9, 35, 45, 94; death
of, 37, 53, 88, 147, 148; "Drella"
nickname, 49, 95; effect on art
history, 123, 126; effete charm of
works, 146; fiction about, 72; film
footage of, 70; financial circum-
stances, 122–123, 124, 125, 130; first
death of, 102–103, 104–105, 120;
homosexuality of, 11–12, 75–76,
81; ideas from other people for
subjects, 32–33, 35, 41–44, 71, 91,
111, 118, 142; identity/identity
changes, 1, 2, 4–5, 8, 17, 47–48,
145–147; influences on, 10, 14, 25,
70; in Italy, 117; last studio, *138*;
mechanical production methods,
49–51, 58–59, 60, 61, 62, 73, 115,
127; novel by, 83; Ondine and,
96–97; ordinary American life
portrayed by, x, xv, 2–3, 4, 22–23,
56–57, 73, 83, 88, 144; patriotic
aspects of works, 73; personality,
49, 70, 88, 118–119, 127, 132, 141;
philosophy of art and, 135–136;
photography and, 65; physical
appearance, 12, 20, 44–45, 75,
85 86, 112, 119; politics and, 56,
73, 116–117; as Pop artist, xi, 4,
13, 32, 33, 45, 47, 58; price of
works, 122; psychological scars
from attempted assassination,
104–105, 125, 131; public persona
of, 45; reconfiguration of art by,
48; religiousness of, 139–141, 142,
145; reputation as an artist, 122;
retirement from painting, 74, 81,
105–106, 108, 110, 121–122; sale
of works, 46; sculptures/three-
dimensional objects, 49, 74; serial
display of works, 34–35, 39; sex
portrayed in works, 141–142; as
television artist, 85, 86, 87, 88–89,
90; as transvestite, 112; as TV
artist, 83, 84–85; universal same-

161